Journal
Tips & Tricks

© 2018 Instituto Monsa de ediciones.

First edition in 2018 by Monsa Publications,
an imprint of Monsa Publications Gravina 43
(08930) Sant Adrià de Besós. Barcelona (Spain)
T +34 93 381 00 50
www.monsa.com monsa@monsa.com

Art director & layout Eva Minguet
(Monsa Publications)
Translation by SOMOS Traductores
Cover image @lets.talk.about.bullet
Back cover image @the.whimsical.journal
@deluxe.journaling @dailydotssk @wood_bujo
Printed by Impuls45 Spain

ISBN: 978-84-16500-99-4
B 27897-2018

Order at:
www.monsashop.com

Follow us!
Instagram: @monsapublications
Facebook: @monsashop

Journal

Tips & Tricks

By Eva Minguet

monsa

WISHLIST

DREAMING
AFTER ALL, IS A
FORM OF
PLANNING
♡
— GLORIA ST

16
17
18
19
20
21
22
23
24
25
26
27
28
29
30

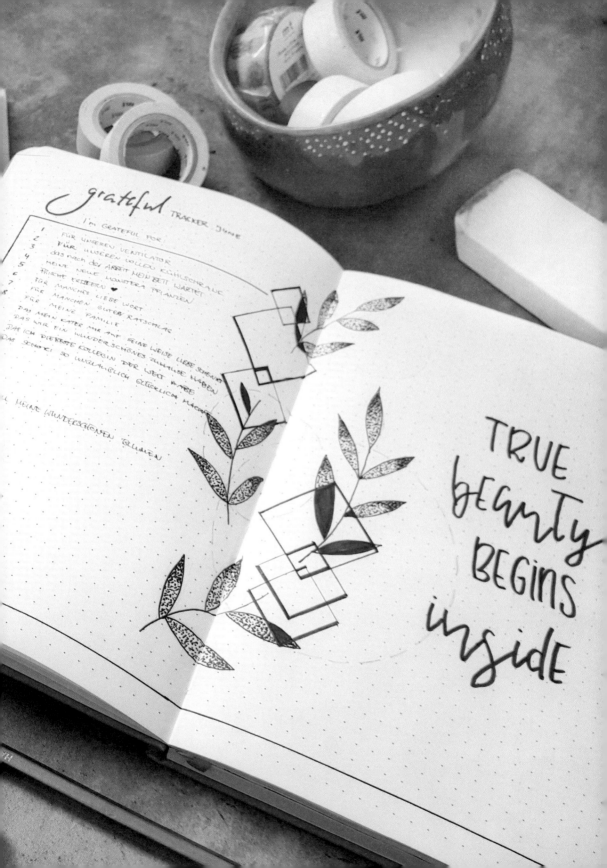

grateful TRACKER JUNE

I'm grateful for

1. FÜR UNSEREN VENTILATOR
2. FÜR UNSEREN VOLLEN KÜHLSCHRANK
3. DAS NACH DER ARBEIT MEIN BETT WARTET
4. MEINE NEUE MONSTERA PFLANZEN
5. FRISCHE ERDBEEREN ♥
6. FÜR MANCHEN GUTEN RATSCHLAG
7. FÜR MEINE FAMILIE
8. DAS MEIN KATER MIR AUF SEINE WEISE LIEBE SCHENKT
9. DAS WIR EIN WUNDERSCHÖNES ZUHAUSE HABEN
10. DAS ICH DIE BESTE KOLLEGIN DER WELT HABE
11. DAS SCHOKI SO UNGLAUBLICH GLÜCKLICH MACHT

FÜR MEINE WUNDERSCHÖNEN BLUMEN

TRUE
beauty
BEGINS
inside

Index

SOME DAYS Y[...]
BUG AND SOME[...]
YOU'RE THE WIN[...]

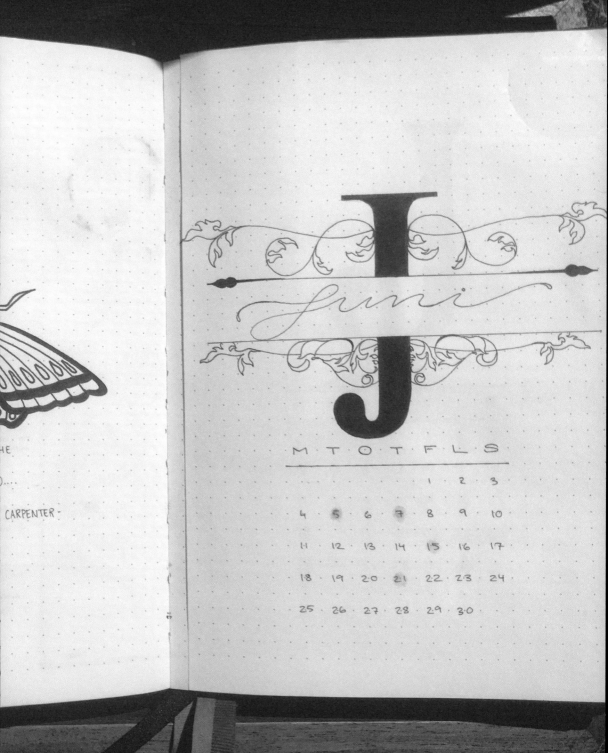

J

Juni

M	T	O	T	F	L	S
				1	2	3
4	5	6	7	8	9	10
11	12	13	14	15	16	17
18	19	20	21	22	23	24
25	26	27	28	29	30	

Introduction

If you are passionate about DIY and simple things, creating your own Journal is the perfect system for you! It allows you to enjoy the usefulness of an agenda but within a completely personalized system, a methodical system that will help you organize your day, month and year.

With all the applications that have been developed to organize your life, at the end of the day there are things, such as making a list of tasks, that continue to work best when written on paper.

With this system you will have one of the most useful, creative and quick tools that you can adapt to your routine without any obligation. It will help you reduce stress by sitting down with it for 5 minutes a day, by improving your memory, by discovering and developing your artistic side, and by achieving your goals.

The popularity of these craft agendas has spread across all social platforms, more than 2 million posts on Instagram, countless suggestions on Pinterest and innumerable YouTube tutorials. Create your own Journal and it will become your best ally to carry out your ideas and to get to know yourself better.

Introducción

Si eres un apasionado del DIY y las cosas simples, ¡crear tu propio Journal es el sistema perfecto para ti! ya que te ofrece la utilidad de una agenda pero con un sistema completamente personalizado, un sistema metódico que te ayudará a organizar tu año, mes y día.

Por muchas aplicaciones que inventen para ordenar tu vida, al final hay cosas como hacer una lista de tareas, que siguen funcionando mejor cuando están escritas en papel.

Con este sistema encontrarás una de las herramientas más útiles, creativas y rápidas que podrás adaptar a tu rutina sin ningún tipo de obligación, te ayudará a liberar el estrés sentándote 5 minutos al día, a mejorar la memoria, a descubrir y desarrollar tu lado más artístico, y a cumplir tus metas.

La fiebre de estas agendas artesanales se extiende por todas las plataformas sociales, más de 2 millones de publicaciones en Instagram, infinidad de sugerencias en Pinterest e innumerables tutoriales en YouTube. Crea tu propio Journal y este se convertirá en tu mejor aliado para llevar a cabo tus ideas y conocerte mejor.

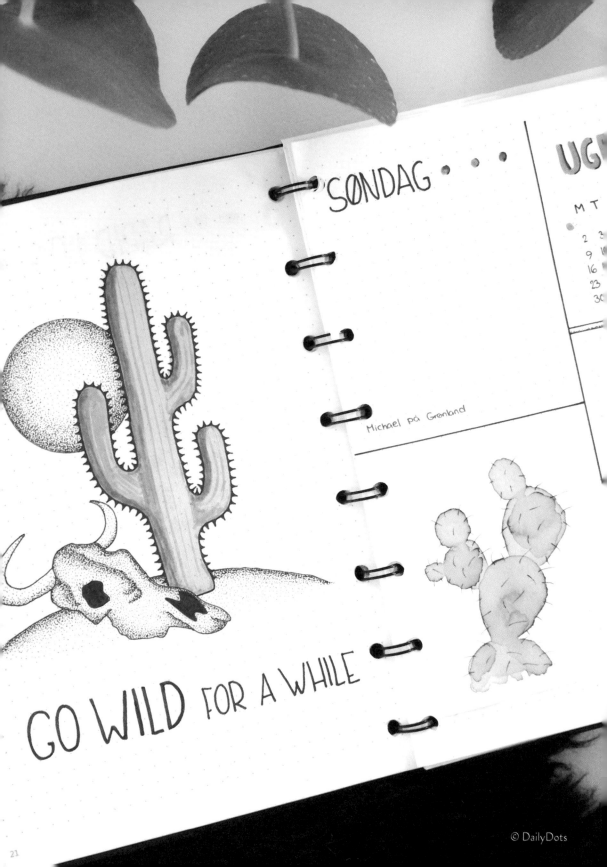

SØNDAG

UGE

M T

2 3
9 10
16
23
30

Michael på Grønland

GO WILD FOR A WHILE

© DailyDots

Notebooks

How to choose a notebook and not regret it

Notebook with hard or semi-hard cover

The hard or semi-hard cover ensures protection for the length of time that you need. You might use it for a whole year, or even more, so it is a decision that must be considered. We have access to different notebooks such as those by Lemome, Leuchtturm 1917 or the Moleskine Classic. Some come with an index at the beginning, numbered pages, a pocket at the end of the notebook to save clippings or photos, and a bookmark, which will help you find your planned week or point of interest.

Size is also very important since it is in your interest if you could always take it with you. You never know when you will receive inspiration or when you will write something that you should not forget. That's why the A5 size is ideal.

Stitched or spiral binding

It is advisable to use a stitched notebook that will allow you to be able to open it completely, which helps when writing or drawing. This type of notebook normally takes up less space since they are narrower. You can also use a spiral or ring notebook, but it can end up being more uncomfortable when working since these types of notebooks do not allow you to place your hand freely in any position, but you will discover that when you begin.

Cómo escoger un cuaderno y no arrepentirte

Cuaderno con tapa dura o semi dura

La tapa rígida o semi rígida te asegura una duración que vas a necesitar. Piensa que lo usarás durante un año entero, o incluso más, así que es una decisión que debe ser meditada. Encontramos diferentes cuadernos cómo los de Lemome, Leuchtturm 1917 o el Moleskine Classic. Algunos los encontramos con un índice al inicio, foliación, un bolsillo al final del cuaderno para poder guardar recortes o fotos, un marca páginas, que te ayudará a encontrar tu semana planificada o un punto de interés.

El tamaño también es muy importante, ya que sería interesante que pudieras llevarlo siempre contigo, nunca sabes cuando vendrá la inspiración, o cuando anotarás algo que no debes olvidar, por eso el tamaño A5 es el ideal.

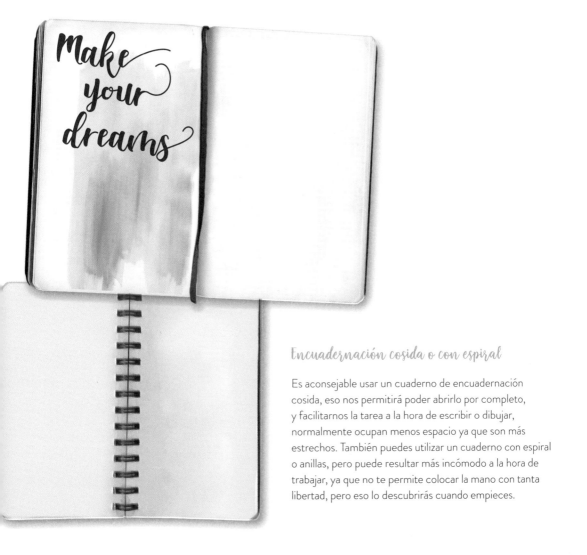

Encuadernación cosida o con espiral

Es aconsejable usar un cuaderno de encuadernación cosida, eso nos permitirá poder abrirlo por completo, y facilitarnos la tarea a la hora de escribir o dibujar, normalmente ocupan menos espacio ya que son más estrechos. También puedes utilizar un cuaderno con espiral o anillas, pero puede resultar más incómodo a la hora de trabajar, ya que no te permite colocar la mano con tanta libertad, pero eso lo descubrirás cuando empieces.

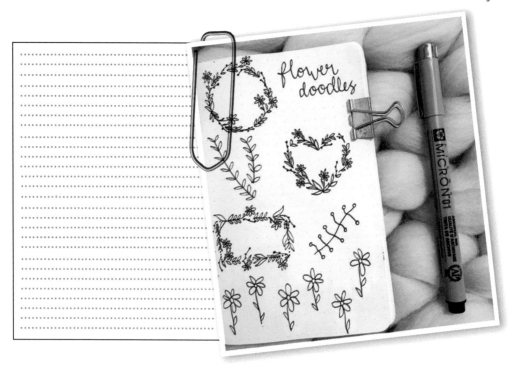

Paper Type: Dotted, blank or graph paper

For your first Journal, it is best that it be filled with dotted or graph paper. This will help you not to mess up, allow you to calculate dimensions in a simple way and to organize your work easily. There is usually a blank margin all around allowing you to jot down notes, decorations or marks.

Paper weight

It is important that the paper doesn't let the drawing medium seep through, so you can use all sorts of materials: watercolors, watercolor brush pens, gel markers, stamps ... That's why we recommend a good weight when choosing your notebook. You do not need a weight of 120 grams, but it should not be too light in order to achieve good results in your compositions.

Tipo de hojas: Punteadas, en blanco o con cuadrícula

Para tu primer Journal, lo mejor es que las hojas sean punteadas o cuadriculadas. Esto te ayudará a no torcerte, a poder calcular las dimensiones de una manera sencilla, y a organizar tu hoja de trabajo fácilmente. Suele haber un margen blanco alrededor, que te permite hacer notas, decoraciones o señales.

Gramaje del papel

Es importante que las hojas no calen, ya que te permitirá usar todo tipo de materiales: acuarelas, pincel de agua con punta de fieltro, rotuladores de gel, sellos... Por eso recomendamos un buen gramaje para la elección de tu cuaderno. No hace falta un gramaje de 120 gramos, pero sí que no sea demasiado inferior para obtener un buen resultado en tus composiciones.

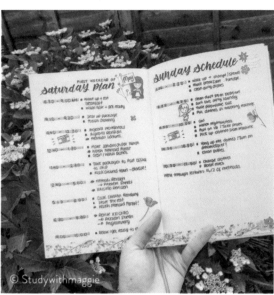

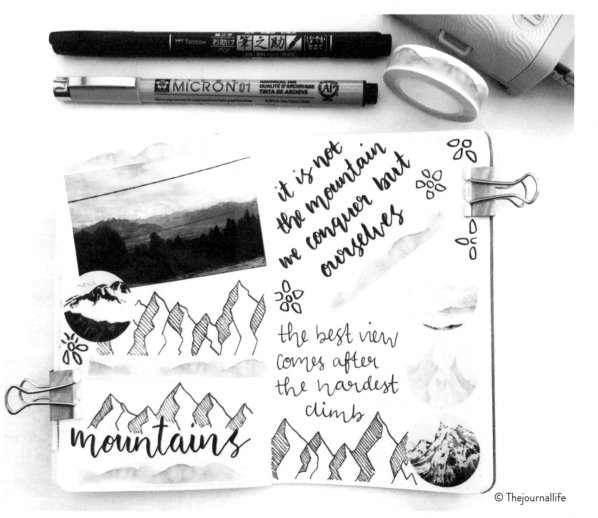

Materials that you can user

You have the freedom to use all types of materials, from blue ballpoint pens, to pencils, to colored markers...

If you've practiced your lines, you can use the "aqua brush" markers that are ideal for lettering and will add style to your sentences or phrases. You can find fine-point or brush-shaped markers of various colors in order to combine them. The ink is usually water based allowing you to blur the lines. There is a wide variety of materials. You can try them out and combine them until you find the ones that go best with your work. Fine and rigid-point brushes tend to be the favorites since they can make a uniform line and are easy to use.

1. Permanent Markers:
Permanent markers are risky to work with but ideal due to their precision. You can find different brands that work with this type of lettering: Micron, Tombow, Kuretake Brush... Permanent markers are usually used for subtitles, drawings, lists or tables.

2. Fine-Point Markers:
They are easy to control and allow you to make smaller-sized cursive letters. The Stabilo brand offers a wide range of colors and also has a range of soft and polychromatic tones.

This is a good option to customize our Journal!

3. Fluorescent Markers
For writing and highlighting tasks or notes in your Journal we recommend the use of markers or fluorescent highlighters They are also for creating different styles of calligraphy or lettering. The most recommended brand is Copic Sketch, which has a double tip and a medium-sized brush and beveled edge. These other brands are equally recommended: Artline, Stabilo Boss, Pelikan.

4. Metallic Markers
These markers are perfect for decorating the pages of our Journal, for creating headings for our lists, weeks or titles. These markers usually offer a wide range of alcohol-based colors. They are permanent and have high quality ink.

5. Acrylic Stamps
Stamps are ideal for creating your creative planner, for making "divider-type" separations, and numbers to be able to date your agenda, as well as points so that you can create your grid.

6. Water Paintings
Watercolors are one of the preferred resources for the Art Journal. They allow you to blur and create soft backgrounds.

© Thejournallife

© Lets.talk.about.bullet

© Mabujork

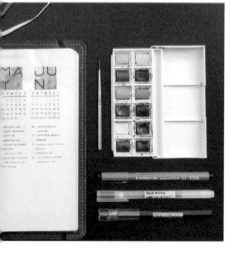

Materiales que puedes usar

Tienes la libertad de usar todo tipo de materiales, desde un bolígrafo de color azul, a lápices, marcadores de colores...

Si has practicado tu trazo, puedes usar los rotuladores "aqua brush" que son ideales para el lettering, y aportarán estilo a tus enunciados o frases. Podemos encontrar rotuladores de punta fina o en forma de pincel, y de diferentes colores para poder combinarlos. La tinta suele ser a base de agua, permitiendo que difuminemos los trazos. Hay mucha variedad de materiales, puedes probar y combinar hasta que encuentres los que más se identifican con tu trabajo. Los pinceles de punta fina y rígida suelen ser los favoritos, ya que aportan un trazo uniforme y son sencillos de usar.

1. Rotuladores permanentes:
Los rotuladores permanentes son arriesgados para trabajar pero ideales por su precisión. Puedes encontrar diferentes marcas que trabajan este tipo de rotulados: Micron, Tombow, Kuretake brush... Este tipo de rotulador suele utilizarse para subtítulos, dibujos, listas o tablas.

2. Rotuladores con punta fina:
Son fáciles de controlar, y permiten hacer letras en cursiva de menor tamaño. La marca Stabilo ofrece un amplio abanico de colores, y también cuenta con una gama de tonos suaves y policromáticos.

¡Una buena opción para personalizar nuestro Journal!

3. Rotuladores fluorescentes
Para marcar y resaltar tareas o notas en tu Journal, recomendamos el uso de marcadores o subrayadores fluorescentes, también para crear diferentes caligrafías o lettering. Los más recomendados son los Copic Sketch, que tienen una punta doble; pincel y biselada de tamaño mediano. Estas otras marcas son igual de recomendables: Artline, Stabilo Boss, Pelikan.

4. Rotuladores metalizados
Estos rotuladores son perfectos para decorar las hojas de nuestro Journal, para crear los encabezados de nuestras listas, semanas o títulos. Estos rotuladores suelen ofrecer una amplia gama de colores de tintas con base de alcohol, permanentes y de una gran calidad.

5. Sellos acrílicos
Los sellos son ideales para crear tu planner creativo, para hacer separaciones tipo "dividers", números para poder fechar tu agenda, puntos para que puedas crear tu retícula.

6. Pinturas al agua
Las acuarelas son uno de los recursos preferidos para el Art Journal. Permiten difuminar y crear fondos suaves.

Organize your life

The importance of planning!

What we present below is a system that allows you to organize your day, week and month with your different events in the form of simple and specific lists. Ryder Carroll created an analog system in a digital world, the Bullet Journal, affectionately called "BuJo." It was created to be a simple planning tool. You only need a blank notebook and a pen. It is not necessary to buy a specific notebook since the different sections are created by hand. A distinguishing feature of a Bullet Journal with respect to an agenda is that it adapts to its own content, without blank spaces, and the information is classified by tasks, appointments or notes. In recent years, people who have committed to this style of planning have done so with sketches, illustrations and details far beyond the design of a simple agenda.

Lists help us to bring order to our day-to-day lives, and to know how to manage our time. They are based on simple and commonly used elements. You can create lists of tasks, objectives, planning a trip, photos, books that you want to read... It is a completely flexible system. It has no limits.

A system of personal organization

We will use a blank notebook for a whole year in which we will write down everything we have to do regularly as a list.

The first thing that we are going to include will be an index. This is essential to be able to locate where you want to turn to within your Journal. All pages must be numbered and include weeks, months, or lists. These are placed in the index to make finding them easier.

Below you will find the "Future Log or Annual Calendar" developed using 4 pages. We will place 6 months distributed on a double page, and the remaining 6 on the next double page. It is a common calendar, which allows you to have a general view of your entire year and to record activities, events, birthdays and appointments beyond the present month.

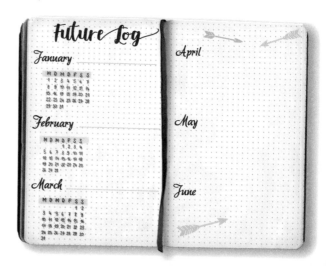

Organiza tu vida

¡La importancia de planificar!

Lo que presentamos a continuación, es un sistema que permite organizar tu semana, mes y día con tus diferentes eventos en forma de listas sencillas y específicas. Ryder Carroll creó un sistema analógico en un mundo digital, el Bullet Journal, llamado cariñosamente "BuJo", fue creado para ser una herramienta sencilla de planificación, sólo se necesita un cuaderno en blanco y un bolígrafo. No es necesario comprar un cuaderno específico, ya que los distintos apartados se crean manualmente. Un rasgo diferencial de un Bullet Journal con respecto a una agenda es que se va adaptando a su propio contenido, sin espacios en blanco, y la información se clasifica con tareas, citas o notas. En los últimos años, las personas que se han comprometido con este estilo de planificación lo han desarrollado con bocetos, ilustraciones y detalles mucho más allá del diseño de una sencilla agenda.

Las listas nos ayudarán a poner orden en nuestro día a día, y a saber gestionar nuestro tiempo, se basan en elementos simples y de uso común. Puedes crear listas de tareas, objetivos, planificación de un viaje, fotos, libros que quieres leer... es un sistema completamente flexible, no tiene límites.

Un sistema de organización personal

Utilizaremos un cuaderno en blanco para todo un año, en el que anotaremos regularmente y a modo de lista todo lo que tengamos que hacer.
Lo primero que vamos a incluir será el índice, este es esencial para poder ubicarte dentro de tu Journal. Todas las páginas han de estar numeradas, y a medida que vas incluyendo semanas, meses, o listas, estas se colocan en el índice para facilitar su búsqueda.

A continuación encontréis desarrollado en 4 páginas el "Future Log o Calendario Anual", colocaremos 6 meses distribuidos en una doble página, y los 6 restantes en la siguiente doble página. Es un calendario común, que te permite tener una mirada general de todo tu año y apuntar actividades, eventos, cumpleaños y citas más allá del mes presente.

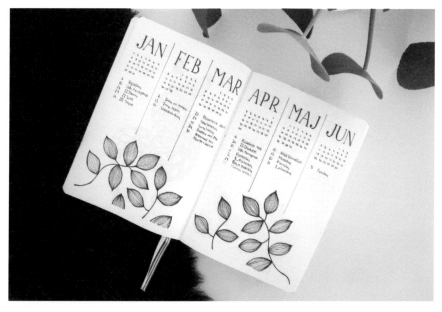

Key

We want to customize our Journal and the best way is by assigning different symbols to each type of task. You can use simpler symbols such as squares, circles, triangles... or drawings that represent the action or reminder you need. You're only limited by your imagination.

You can create as many symbols as you need but remember that you will have to memorize them in order to use them.

Queremos personalizar nuestro Journal, y la mejor manera es asignando diferentes símbolos a cada tipo de tarea. Puedes usar símbolos más sencillos como son los cuadrados, círculos, triángulos... o dibujos que representen la acción o recordatorio que necesitas, el límite está en tu imaginación.

Puedes crear tantos símbolos como necesites, pero recuerda que tendrás que memorizarlos para ir colocándolos.

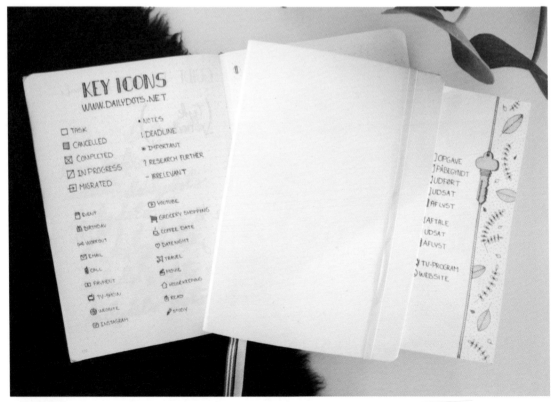

© DailyDots

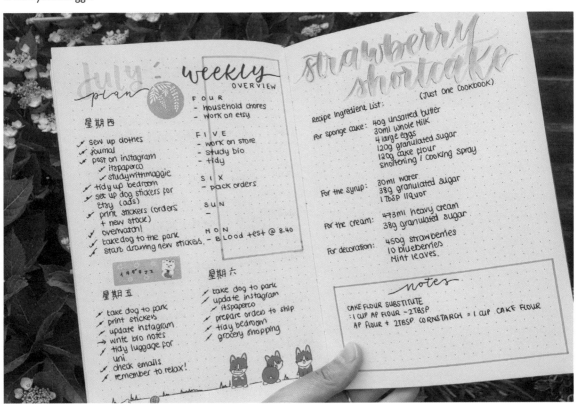

We will also use different colors to quickly recognize if the task is a family event, work meeting, outing with friends...

Below you will see different examples.

También usaremos diferentes colores, para reconocer rápidamente la tarea, si es un evento familiar, reunión de trabajo, salida con amigos...

A continuación verás diferentes ejemplos.

 Citas

 Ideas

 Tareas

 Eventos

 Importante

 Aprobado

 Gastos

———————— Familia

———————— Amigos

———————— Trabajo

———————— General

———————— Personal

———————— Importante

———————— Recordar

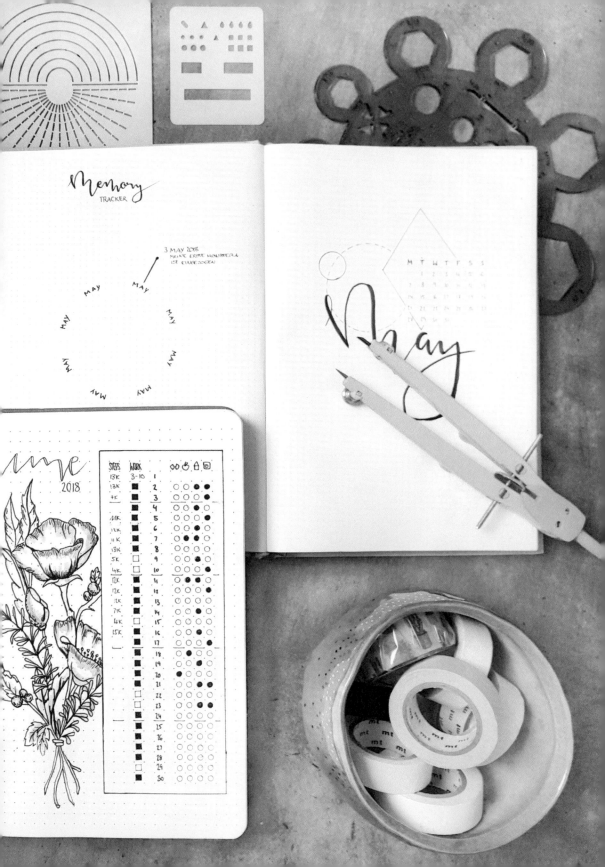

Index

To facilitate your search and to organize your Journal, ideally the first few pages will be dedicated to an index. All pages will be numbered so we can indicate on which page lists or highlighted tasks are located. When we make an entry or list that might interest us in the future, we will note it in the index. This will help us save time and find information quickly. If you run out of space in the index you can always resolve this situation creatively (see page 37).

Para facilitar la búsqueda y tener organizado nuestro Journal, lo ideal será dedicar las primeras páginas al índice. Todas las páginas estarán numeradas, para que podamos indicar en que página se encuentran las listas o tareas destacadas. Cuando escribamos una entrada o lista que nos pueda interesar para el futuro, la dejaremos registrada en el índice. Esto nos ayudará a ahorrar tiempo y a encontrar la información rápidamente. Si te quedas sin espacio en el índice, siempre puedes solucionarlo de forma creativa (consulta la página 37)

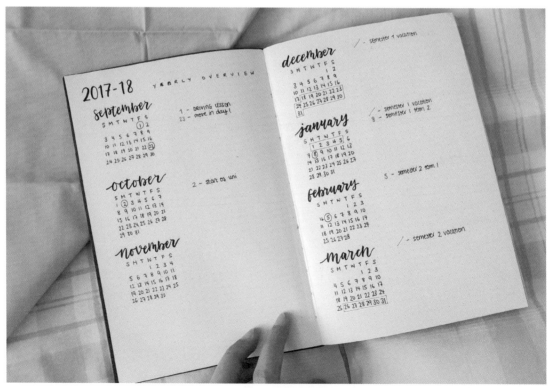

© Studywithmaggie

Record

Annual Log

The goal of the annual record is to organize your highlighted events and to be able to include new events during the year. We can do this in different ways, ideally dedicating a double page. On it we will write down the most important things of the year that we cannot forget: anniversaries, special events, vacations, medical appointments...

Registro Anual

El objetivo del registro anual es organizar los eventos destacados, y poder incluir nuevos eventos durante el año. Podemos hacerlo de diferentes maneras, dedicarle una doble página es lo ideal. Allí anotaremos las cosas más importantes del año que no podemos olvidar. Aniversarios, eventos especiales, vacaciones, citas médicas...

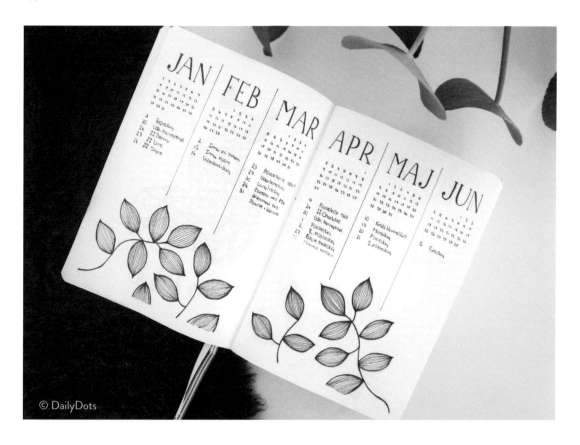

© DailyDots

Monthly Log

Using a monthly record is a way to control the different tasks or commitments for the month. We will write down, in an orderly way, those that are the most noteworthy. You can always add new items that will help us to better plan out our month. We can create it in different ways while respecting sequence and space in order to work better. The monthly record is always useful since will give us peace of mind when it comes to not forgetting goals, events...

Registro Mensual

Usar un registro mensual es una manera de controlar las diferentes tareas o compromisos del mes. Anotaremos de forma ordenada y limpia lo más destacado, siempre se puede acabar de añadir nuevos planes, eso nos ayudará a planificar mejor nuestro mes. Podemos crearlo de diferentes maneras, respetando el orden y el espacio para poder trabajar mejor. Siempre es útil el registro mensual ya que nos aportará tranquilidad a la hora de no olvidar objetivos, eventos...

Daily Log

The daily record will focus on a closer moment. This will offer you a way to express yourself on a personal level, turning it into a moment of reflection and appreciation of the day. Enjoying the process is important in order to continue to want to draw and write in your Journal. Every day is different and that is what makes our stories unique. You can use decorative details such as those presented on page 32.

Registro Diario

El registro diario lo enfocaremos a un momento más personal, esto te ofrecerá una vía para expresarte a nivel personal, convirtiéndolo en un momento de reflexión y valoración del día. Disfrutar del proceso es importante para seguir deseando dibujar y escribir en tu Journal, cada día es diferente y eso es lo que hace que nuestras historias sean únicas. Puedes usar detalles decorativos como los que presentamos en la pág 32.

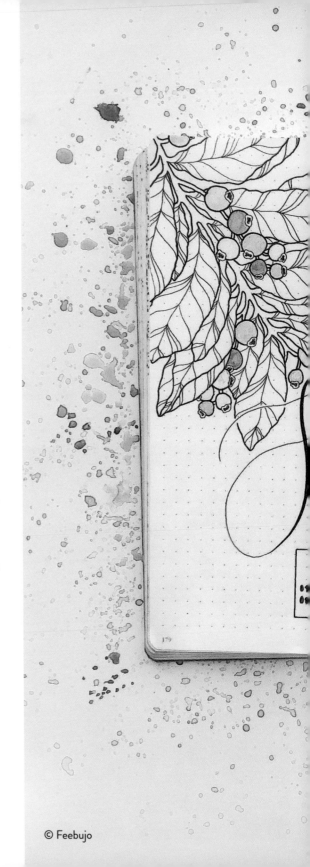

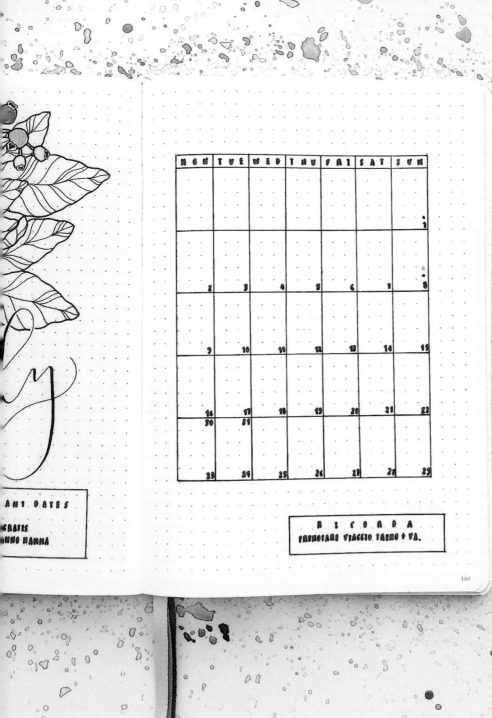

MON	TUE	WED	THU	FRI	SAT	SUN
						1
2	3	4	5	6	7	8
9	10	11	12	13	14	15
16	17	18	19	20	21	22
30	31					
23	24	25	26	27	28	29

ANT DATES

GRATIS
NNO MAMMA

R I C O R D A
PRENOTARE VIAGGIO TRENO + VA.

Lists

Lists are an excellent way to keep your thoughts organized. We can make lists of everything we think of. For example, books that we would like to read, or that we have read and want to evaluate, movies and series, projects, tasks in which you must work and finish within a specific period of time...

In addition to keeping everything in the form of a list, you can try to explore a more illustrative approach. You can write some elements by hand or use icons as bullets to make your lists more dynamic.

listas

Las listas son una excelente manera de mantener tus pensamientos organizados. Podemos hacer listas de todo lo que consideremos; por ejemplo libros que nos gustaría leer, o que hemos leído y queremos puntuar, películas y series, proyectos, tareas en las que debes trabajar y terminar en un período de tiempo específico...

Además de mantener todo en forma de lista, podemos intentar explorar un enfoque más ilustrativo: puedes escribir a mano algunos elementos o usar iconos como viñetas para hacer que tus listas sean más dinámicas.

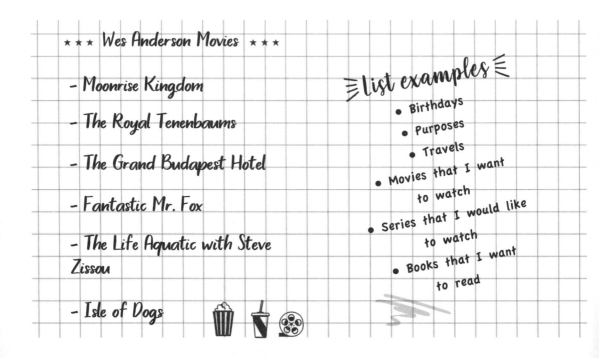

★ ★ ★ Wes Anderson Movies ★ ★ ★

- Moonrise Kingdom
- The Royal Tenenbaums
- The Grand Budapest Hotel
- Fantastic Mr. Fox
- The Life Aquatic with Steve Zissou
- Isle of Dogs

list examples
- Birthdays
- Purposes
- Travels
- Movies that I want to watch
- Series that I would like to watch
- Books that I want to read

GOALS

- ■ DELIVER ANGELI & DAVID'S PHOTOG PACKAGE
- ■ FINISH BASEBOARDS
- ◩ CLEAN OUT CLOSET
- ◩ RE-WORK PHOTOG LOGO
- ⊟ ~~BUY BIT COIN~~
- ◩ FIND WORKOUT ROUTINE
- ■ AILENE & JOHN'S WEDDING TIMELINE
- ■ BACK-UP IPHONE PHOTOS
- ■ FIX RAIN GUTTER
- ◩ BUSINESS CARDS
- ◩ CREATE A PINTEREST FOR PHOTOG BUSINESS
- ◩ UPDATE WEBSITE PHOTOS
- ◩ OIL CHANGE
- ⊟ ~~TAKE CARL TO VET FOR CHECK-UP~~

NOTES

- – GET COFFEE UNIQUE TO SEATTLE DURING TRIP
- – PHOTOG GOALS:
 - • EDUCATION
 - • SHOOT OFTEN (WITH FILM !)
 - • BRANDING
 - • BOOK MORE CLIENTS
- – MUSIC TO DOWNLOAD
 - • "OUTSIDE" – SAMWISE
 - • "BEAM" – PETIT BISCUIT
 - • "LOVE" – GHALLOU



...O AM

...NG SESH #3

...TLE, 7:09 PM

...T BACK TO RENO,
...2 PM

...INING SESH #4

...WITH ALEX @ HUB
...RIVER, 3 PM

...SH ELAINE & NHIN'S PHOTOS

...NISH SON FAM PHOTOS

...OG TRAINING SESH #6

10

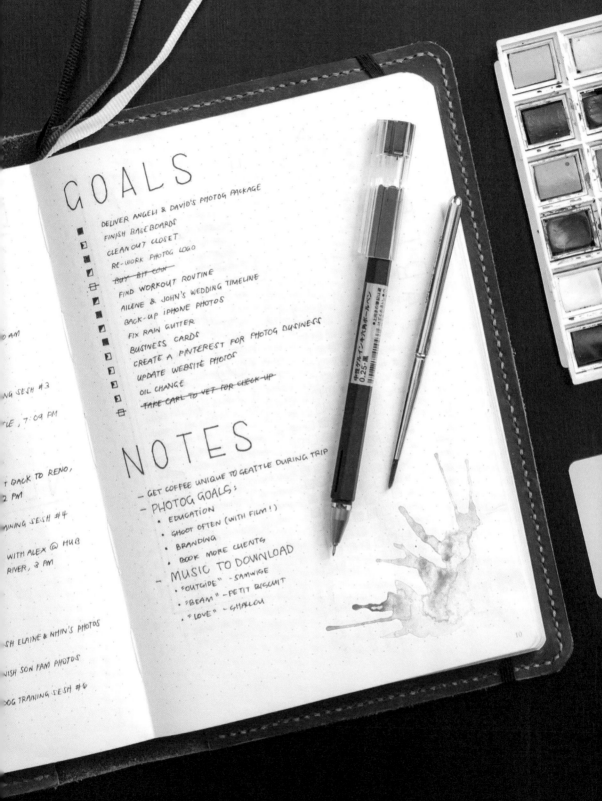

Unleash your creativity

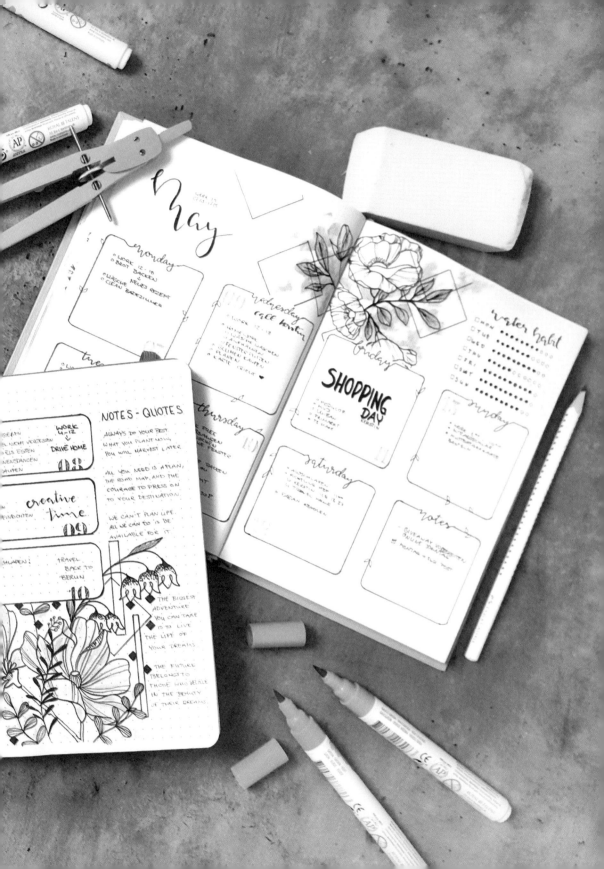

Embellishments

Here are samples of decorative elements that you can use. This will help you personalize your pages even more. Enjoy!

Aquí hay muestras de adornos que puedes usar. Esto te ayudará a personalizar aún más tus páginas. ¡Disfrútalo!

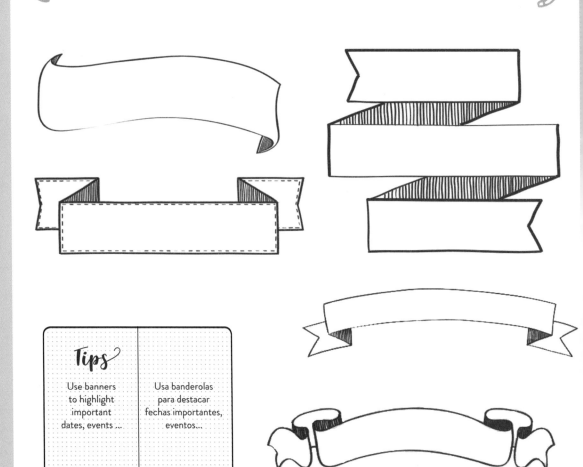

Tips

Use banners to highlight important dates, events …

Usa banderolas para destacar fechas importantes, eventos…

Doodles Design Element

Ornaments

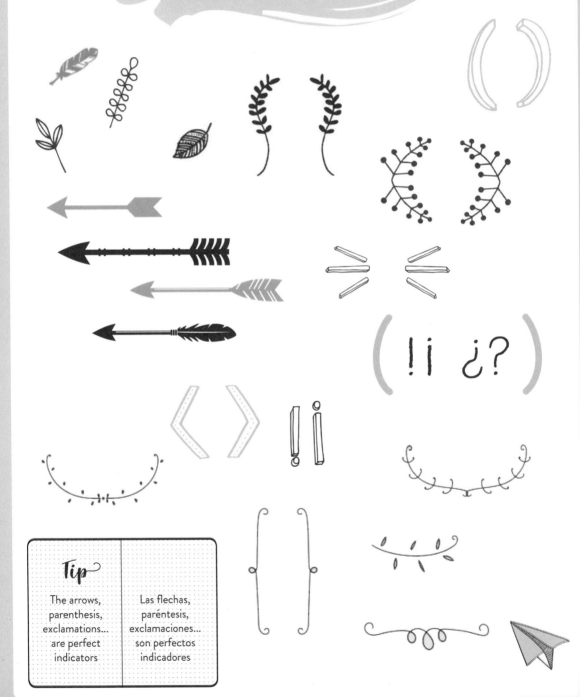

Washi Tape

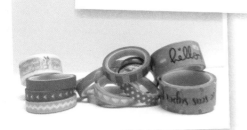

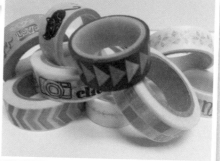

Tip

Use Washi Tape to decorate and stick photos, cards...

Utiliza los Washi Tape para decorar y poder pegar fotos, tarjetas...

Journal inspired

Below we present the works of different artists. You can get to know their most personal way of looking at things and images of how they design their Journals, how they organize and decorate them, and the materials they prefer to use when working in them. We will see how exciting it can become and how many ways to create a Journal, how to create records and how to highlight what we consider relevant. All this accompanied by the exquisite work of 17 designers with very personal styles who combine their work or studies with their passion, lettering, beautiful designs, and organization through lists, calendars, tasks...

You will find designs such as: The coloring and illustrations by Christina *Christina77star* on page 48, continuing with the clean outlines of Catja *Deluxejournaling* on page 58, the exquisite Mone *Lets. talk.about.bullet* on page 82, and also those of Maggie *Studywithmaggie* on page 106, who combines Washi Tape and stickers to bring freshness and a cuter touch to her pages.

You will come to know the personal experience of Anna *Alukewarmmess* on page 78, that through her Journal she managed to fight anxiety and depression. She uses an iPad Pro, something that's not very common, but with which she obtains amazing results, and as she says "Discovering that my records can make others not feel so lonely has helped me enormously and has given me a purpose. Also, sometimes I'm funny and I make people laugh!"

A continuación presentamos los trabajos de diferentes artistas. Podréis conocer su mirada más personal e imágenes de como diseñan sus Journals, como los organizan y decoran, y que materiales prefieren usar para trabajar. Veremos que apasionante puede llegar a ser, y cuantas formas hay de hacer un Journal, como crear registros y como saber destacar lo que consideremos de relevancia. Todo esto acompañado por el exquisito trabajo de 17 diseñadoras con estilos muy personales, que combinan su trabajo o estudios con su pasión, el lettering, los diseños bonitos, y la organización a través de listas, calendarios, tareas...

Encontraréis diseños como: Los coloridos e ilustrados de Christina *Christina77star* en la pág 48, pasando por los limpios y esquemáticos de Catja *Deluxejournaling* pág 58, los exquisitos de Mone *Lets.talk.about.bullet* pág 82, y también los de Maggie *Studywithmaggie* pág 106, que combina los Washi Tape y las pegatinas para aportar frescura y un toque más cute a sus páginas.

Conoceréis la experiencia personal de Anna *Alukewarmmess* pág 78 que a través de su Journal consiguió luchar contra la ansiedad y la depresión. Ella utiliza un iPad Pro, algo poco común, pero con el que obtiene unos resultados asombrosos, y como ella misma dice "Descubrir que mis registros pueden hacer que otros no se sientan tan solos, me ha ayudado enormemente, me ha dado un propósito. Además, ¡a veces soy graciosa y hago reír a la gente!".

June

MON	TUE	WED	THU	FRI	SAT	SUN
				1	2	3
4	5	6	7	8	9	10
11	12	13	14	15	16	17
18	19	20	21	22	23	24
25	26	27	28	29	30	

IMPORTANT DATES

02/06 FESTA DELLA REPUBBLICA
14/06 COMPLEANNO PAPÀ

RICORDA
FINIRE PRIMA PARTE AL LT. FINE MESE

Featured artists

Bujotrulla

Instagram: @bujotrulla

1) What can we find in your journal?
My Bullet Journal collects important appointments,events and birthdays along with a lots of listings. To-do and brainstorming lists as well as lists of TV shows, movies and books. It not only reminds me of things I must not forget, but also records those things I want to remember. That way I would combine the calender (future log, monthly and weekly plans) with my personal thoughts and notes.

2) What materials do you use to create it?
Of course I need a notebook. Mine is always dot grid and has thick white paper, so the pens don't bleed through. I also need a pencil to sketch and of course a good eraser. Furthermore I use different pigment liner for drawing and writing and Brushpens for my lettering.

3) How do you organize the pages to create your journal?
All long-term events will be represented in an annual overview, my future log, which always takes up the first few pages of every book. Every new month I would start with a monthly setup, which is preceded by a monthly overview, which in turn assists me with my weekly plans. That's how everything builds upon on another. I would layout my pages with floral designs, unobstrusively and mostly monochrome, so they would not be too much of a distraction from my entries. Designing page layouts is almost like meditation for me more or less time consuming at times. This way my calender will adapt to myself as needed, not the other way around.

1) ¿Qué podemos encontrar en tu journal?
Mi Bullet Journal recopila citas importantes, eventos y cumpleaños, junto con muchos listados. Lista de tareas pendientes, lluvias de ideas, así como listas de programas de televisión, películas y libros. No solo me recuerda cosas que no debo olvidar, sino que también registra aquellas cosas que quiero recordar. De esa manera, combinaría el calendario (registro futuro, planes mensuales y semanales) con mis pensamientos y notas personales.

2) ¿Qué materiales usas para crearlo?
Por supuesto, necesito un cuaderno. El mío siempre es punteado, tiene hojas de papel blancas y gruesas, y así los bolígrafos no calan. También necesito un lápiz para dibujar y por supuesto, una buena goma de borrar. Además, utilizo diferentes liners (delineadores) para dibujar y escribir, y bolígrafos tipo pincel para mis Letterings.

3) ¿Cómo organizas las páginas para crear tu journal?
Todos los eventos a largo plazo se anotarán en mi registro futuro, que siempre ocupa las primeras páginas de cada Journal. Cada mes nuevo, comienzo con un registro mensual, que está precedido por un resumen, que a su vez me ayuda con mis planes semanales. Así es como una cosa se va construyendo sobre la otra. Compongo mis páginas con diseños florales, y en su mayoría monocromáticas, para que no me distraigan de mis apuntes. Crear diseños de páginas es para mí casi como meditar, consumiendo a veces más o menos tiempo. De esta manera, mi calendario se adaptará a mí según sea necesario, y no al revés.

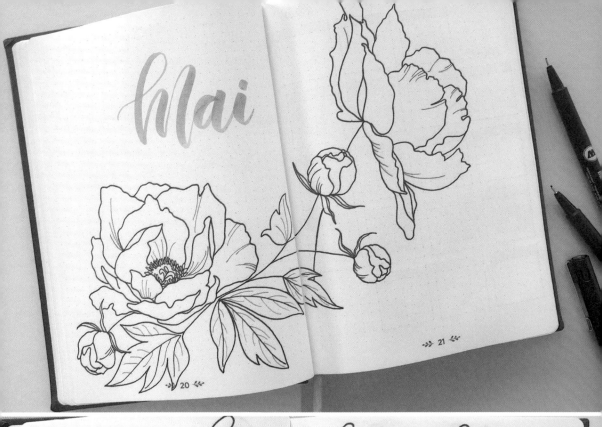

Mai

20 21

jahres-übersicht

2018 2019

sep

okt

jan

feb

nov

dez

mär

apr

4

14-20

Mai

MONTAG 14

* HOLGER HAT
 FRÜHSCHICHT
 (HUNDE INS WZ
 SPERREN)
o HAUTARZT TER-
 MIN MACHEN
• EMIL T-SHIRTS
 UND SCHLAFANZÜGE
 BESTELLEN (ZALAN-
 DO)
• TASSE FÜR EVI
 BEMALEN

DIENSTAG 15

• HUNDEFUTTER FÜR
 TRULLA BESTELLEN
 (TIERARZT)
• WÄSCHE WASCHEN
 (SCHWARZ)
x STAUBSAUGEN
x KÜCHE
x KINDERZIMMER

MITTWOCH 16

• WÄSCHE
 WASCHEN
 (BUNT, 30°)
• HUNDEGASSI MIT
 MAMA

* TRULLA TIERARZT
 (BLASENENTZÜN-
 DUNG)

...NERSTAG 17

- ...CHE WASCHEN
 (...WARZ, BUNT)
- ...ÄUMEN
- ...SIRUNDE
 (...A KOMMT MIT)
- ...FEDERMAPPE

- ...BOS
- ...OLGER;
- ...CKE FÜR
 ...)
- ...PT MITGE-

FREITAG 18

- TRULLA ANTI-
 BIOSE MORGENS
- SACHEN PACKEN
- HUNDETASCHE
 PACKEN
 - HAUSARBEIT:
 x WÄSCHE
 x STAUBSAU-
 GEN (EG)
 - SCHUHE
 PUTZEN
- BADEWANNE
- HAARE FÄRBEN

...TAG 19

...lin

- ...HRT 10 UHR

- ...E ZU HOLGER
 ...ABINE.
 ...EN

SONNTAG 20

berlin

Instagram: @feebujo
Facebook: @feebujo
www.etsy.com/shop/feebujoshop

1) What can we find in your journal?
In my Journal you can find a part of my life, all my tasks, my goals, my creativity, I include in my Journal all things that are important to me, every person has different needs to keep. I combine the tasks of my everyday life with my passions of drawing and nature and I create my layout without patterns, I organize the pages according to my requirements.

2) What materials do you use to create it?
For my layout I use micron pens of different tips, stabilo pens, pastel colors and watercolors.

3) How do you organize the pages to create your journal?
Every week I organize my weekly layout according to my commitments if I have so much to do in those days I organize the layout with a day for page, otherwise I use my usually layout with 7 days in two pages.

1) ¿Qué podemos encontrar en tu journal?
En mi Journal puedes encontrar una parte de mi vida, todas mis tareas, mis objetivos, mi creatividad. En él incluyo todas las cosas que son importantes para mí, ya que cada persona tiene diferentes necesidades que satisfacer. Combino las tareas de mi vida cotidiana con mi pasión por dibujar y por la naturaleza, creo mi diseño sin patrones, organizando las páginas según mis necesidades.

2) ¿Qué materiales usas para crearlo?
Para mi diseño utilizo bolis Micron de diferentes puntas, bolígrafos Stabilo, colores pastel y acuarelas.

3) ¿Cómo organizas las páginas para crear tu journal?
Cada semana organizo mi diseño semanal de acuerdo con mis compromisos; si tengo mucho que hacer en esos días, organizo el diseño con un día por página. De lo contrario, uso mi diseño generalmente con 7 días en dos páginas.

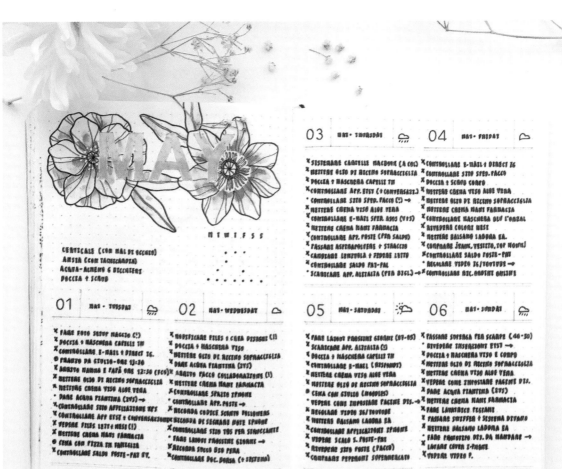

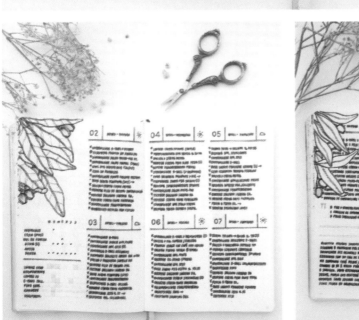

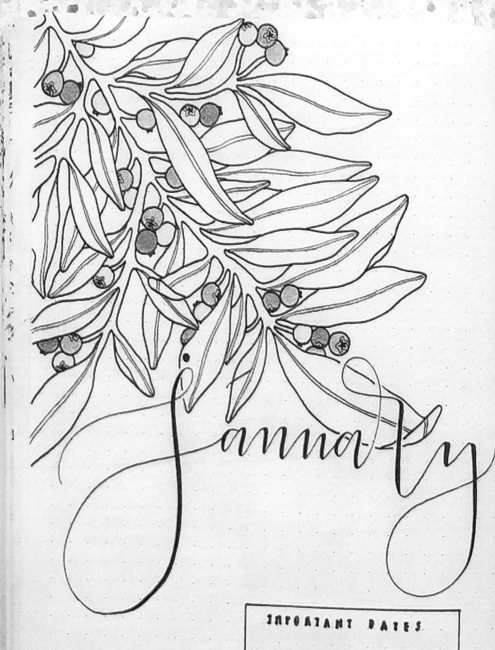

January

IMPORTANT DATES

01/01 CAPODANNO
06/01 EPIFANIA
13/01 NUOVI ARTICOLI SHOP

MON	TUE	WED	THU	FRI	SAT	SUN
1	2	3	4	5	6	7
8	9	10	11	12	13	14
15	16	17	18	19	20	21
22	23	24	25	26	27	28
29	30	31				

RICORDA
STAMPE + TISCR. CORSO CON CARTA

Christina

www.christina77star.net
Instagram: @christina77star
Facebook: christina77starcommunity

1) What can we find in your journal?
My bullet journal can take any form I want and I can create any spread in it that will help me reach my goals in any aspect of my life. It's an amazing tool that helps me to corral all my to-do lists, random slips of papers, notes, ideas, and recommendations into one place, and it offers me peace of mind.

Apart from my monthly, daily and weekly planning, I've also been using it for various things, like to create healthy morning habits, or to keep up with monthly wellness challenges (like the Miracle Morning - 30 Day Life Transformation challenge). I also use it to create the weight loss plan I want to follow with my exercise routine, and a monthly meal plan that will help me get back on track. I track my finances, my daily mood and I also keep a gratitude log as well. Lastly, I use my trackers to keep up with all the things that matter to me - from how many hours I sleep, to how much water I drink and if I meditate every day.

You can literally do anything you want in your bullet journal. Plus, by sharing it with the lovely online community, it helps me stay accountable to my goals even more.

2) What materials do you use to create it?
When you start bullet journaling, the only thing you'll need is a notebook (any type of notebook will do) and your favourite pen. It's that simple :) However, I have a few tools that I love to use and I always recommend them:

SCRIBBLES THAT MATTER notebook, A5 size. FABER-CASTELL ECCO PIGMENT pens. TOMBOW DUAL BRUSH markers.

3) How do you organize the pages to create your journal?
Bullet journaling is a planning system that shows you how to create your own planner one day at a time and to add spreads and collections as you go along.

So, my main page organisation starts when I have a brand new bullet journal. That's the time where I can choose and organise which spreads and collections I want to keep in the new journal. I take my time to put them in the order I want, and I also take notes of any changes I want to make. These spreads usually include my Key and Colour Code, Year at a Glance page, Future Log, Birthdays and Holidays spread etc.

From that point on, I start using the bullet journal as normal. That means that I tend to plan my monthly pages in advance, which includes creating all my weekly spreads as well. But once that's done, I keep on adding pages and spreads as I go along, depending on what I want to include in my bullet journal at the time.

When you're bullet journaling, your collections and spreads will be in between your dailies and your weeklies and that's fine, because you have an index in the beginning of your journal where you note everything down. Therefore you know exactly on which page everything is.

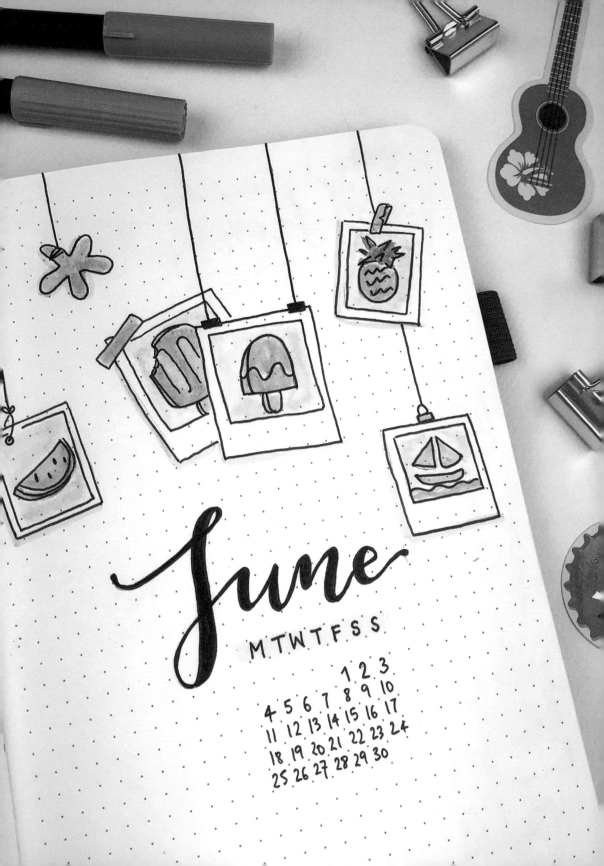

June

M T W T F S S

1 2 3
4 5 6 7 8 9 10
11 12 13 14 15 16 17
18 19 20 21 22 23 24
25 26 27 28 29 30

Christina

1) ¿Qué podemos encontrar en tu journal?

Mi diario puede tomar cualquier forma que desee y puedo crear cualquier apartado que me ayude a alcanzar mis metas en cualquier aspecto de mi vida. Es una herramienta increíble que me ayuda a agrupar todas mis listas de tareas, hojas de documentos, notas, ideas y recomendaciones al azar en un solo lugar, y me aporta tranquilidad.

Además de mi planificación mensual, diaria y semanal, también lo uso para varias cosas, como crear hábitos saludables por la mañana o mantener los desafíos mensuales de bienestar (como el desafío "Miracle Morning - 30 Day Life Transformation" - "Mañanas milagrosas - transformación en 30 días"). También creo un plan de pérdida de peso que quiero seguir con mi rutina de ejercicios y un plan de comidas mensual que me ayudará a volver a la normalidad. Hago un seguimiento de mis finanzas, de mi estado de ánimo diario y también mantengo un registro de agradecimiento. Por último, uso mis listas de hábitos para estar al día con todas las cosas que me importan, desde cuántas horas duermo, hasta cuánta agua bebo y si medito todos los días.

Literalmente, puedes hacer lo que quieras en tu Journal. Además, al compartirlo con mis seguidores en redes, me ayuda a ser más responsable con mis objetivos.

2) ¿Qué materiales usas para crearlo?

Cuando inicies un Journal, lo único que necesitarás es una libreta (cualquier tipo de libreta) y tu bolígrafo favorito. Es así de simple :-) Sin embargo, tengo algunas herramientas que me encanta usar y siempre las recomiendo:

Cuaderno SCRIBBLES THAT MATTER, tamaño A5.
Bolígrafos FABER-CASTELL ECCO PIGMENT.
Rotuladores TOMBOW DUAL BRUSH.

3) ¿Cómo organizas las páginas para crear tu journal?

Llevar un Journal es un sistema de planificación que te muestra cómo crear tu propia agenda día a día y cómo añadir apartados y colecciones a medida que avanzas.

Por lo tanto, la organización de mi página principal comienza cuando tengo un estilo nuevo de Jornal. Ese es el momento en el que puedo elegir y organizar los apartados y colecciones que quiero conservar en el nuevo diario. Me tomo mi tiempo para ponerlos en el orden que quiero, y también tomo notas de cualquier cambio que quiera hacer. Estos apartados, por lo general, incluyen mi "Key" y Código de color, Año, Índice, Calendario anual, Cumpleaños, Días festivos, etc.

A partir de ese momento, empiezo a usar el Journal de manera normal. Eso significa que tiendo a planificar mis páginas mensuales por adelantado, lo que incluye también la creación de todos mis apartados semanales. Pero, una vez hecho esto, sigo agregando páginas y apartados a medida que avanzo, en función de lo que quiera incluir en mi diario en ese momento.

Cuando realices un Journal, tus objetivos y listas, estarán siempre presentes, y eso está bien, porque dispones de un índice al principio en el que anotas todo. Por lo tanto, sabes exactamente en qué página está todo.

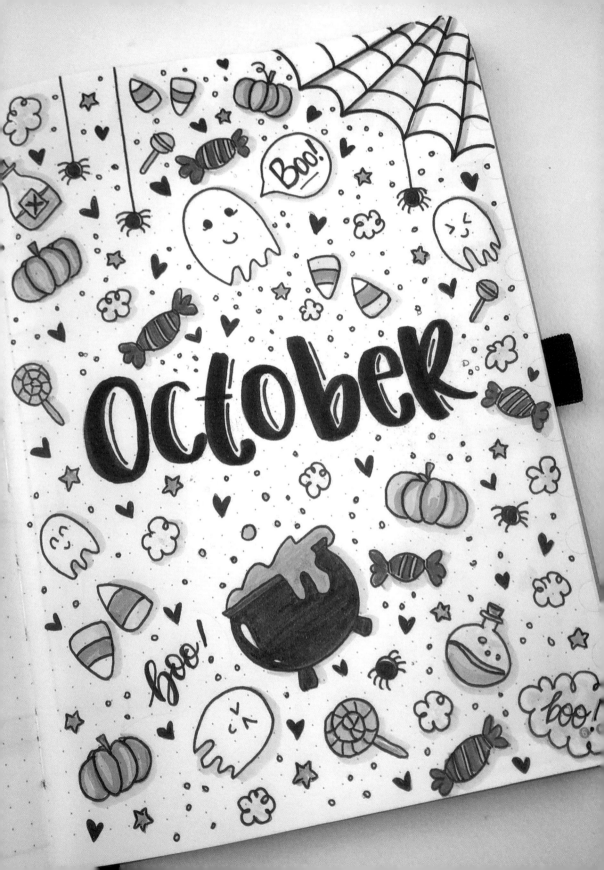

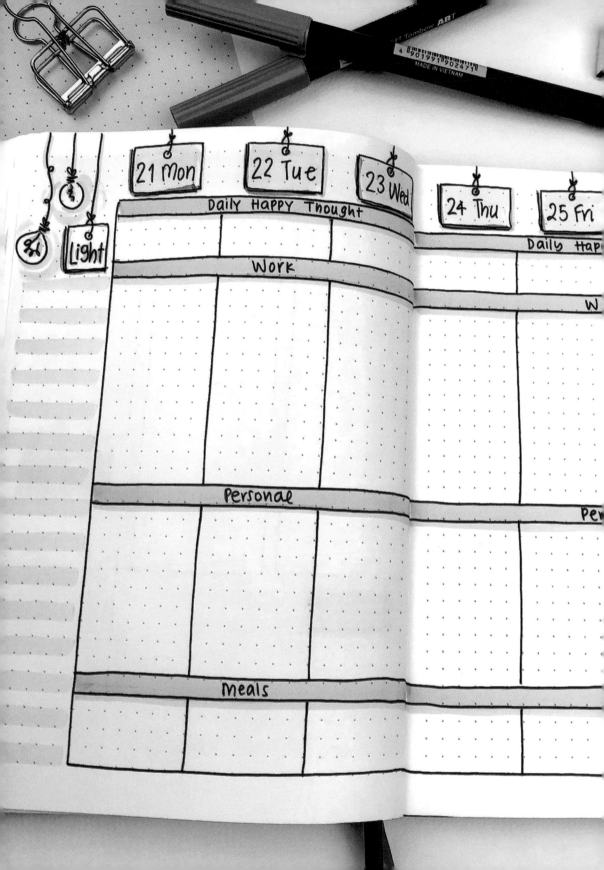

21 Mon **22 Tue** **23 Wed** **24 Thu** **25 Fri**

Light

Daily Happy Thought

Work

Personal

Meals

Daily Hap

W

Per

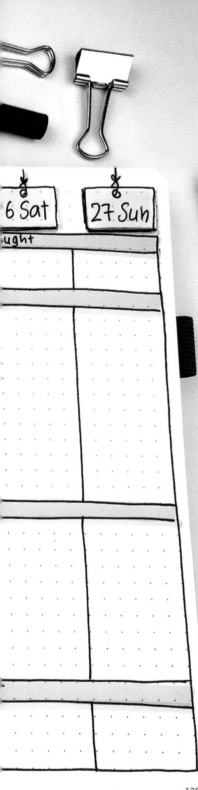

6 Sat | 27 Sun

ught

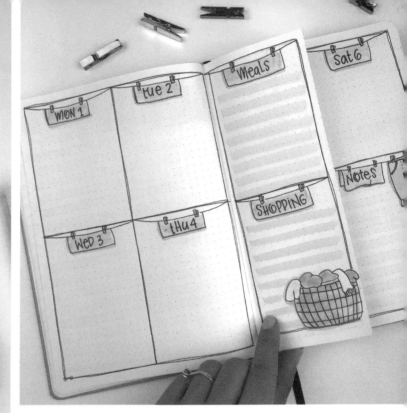

MON 1 | tue 2 | MEALS | Sat 6

WED 3 | tHu 4 | SHOPPING | Notes

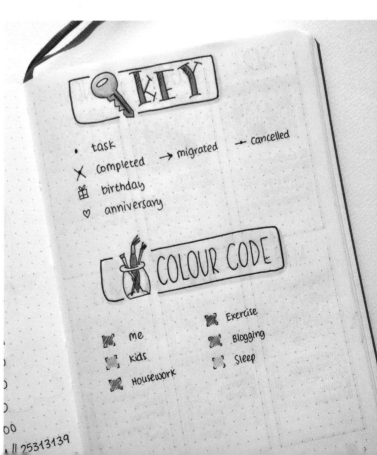

KEY

- task ✗ Completed → migrated → Cancelled
- ✗ Completed
- 🎁 birthday
- ♡ anniversary

COLOUR CODE

- me
- Kids
- Housework
- Exercise
- Blogging
- Sleep

the journal life

www.thejournallife.co.uk
Instagram: @the.journal.life

1) What can we find in your journal?
I have 2 journals that I use daily, a diary style journal which I use for my monthly spreads and weekly plans and then my doodle, brain dump journal which I use for everything else. In the latter journal you'll find everything from song lryics - to practice my handwriting, to doodles, galaxy planets and bucket lists. My journals are my creative outlet and I fill them with a variety of things dependent on my mood.

2) What materials do you use to create it?
I use a mixture of medias to create my journal entries. From brush pens, to watercolours and metallic paints to washi tapes, stickers and cuttings from magazines, I like to use colour, but I also like to use black and white. I am a huge fan of keeping things simple, I think this look is always effective, however that doesn't meant to say that I'm not partial to a busy spread every now and then too.

3) How do you organize the pages to create your journal?
As I have 2 journals it is quite easy for me to keep the two areas separate. My diary style journal is exactly that, a monthly and weekly plan of my life. My brain dump journal on the other hand is a bit of a jumble of different pages throughout. I take each page and fill it with whatever my creativity desires. My life is busy but fairly organised, so my brain dump journal is one of the only areas of it that allows me to be a bit chaotic, I love it!

1) ¿Qué podemos encontrar en tu journal?
Tengo 2 Journals que uso cotidianamente, uno de estilo agenda que utilizo para mis apartados mensuales y planes semanales y luego mi cuaderno de doodles, el Journal donde vuelco todo lo que tengo en mi cabeza, el cual utilizo para todo lo demás. En este último encontrarás de todo, desde letras de canciones hasta la práctica de mi Lettering, bocetos, dibujos de planetas y galaxias, y listas de cosas que hacer antes de morir. Mis Journals muestran mi lado más creativo, una variedad de cosas que dependen de mi estado de ánimo.

2) ¿Qué materiales usas para crearlo?
Utilizo una mezcla de medios para crear mis Journals. Desde bolígrafos, acuarelas y pinturas metálicas hasta cintas washi, adhesivos y recortes de revistas; me gusta usar colores, y también trabajar en blanco y negro. Soy una gran fan de mantener las cosas simples, creo que este aspecto siempre es efectivo. Sin embargo, eso no significa que no sea parcial a la hora de ocupar todo el espacio de vez en cuando.

3) ¿Cómo organizas las páginas para crear tu journal?
Como tengo 2 Journals, es bastante fácil para mí mantener las dos áreas separadas. Mi diario de estilo cotidiano es exactamente eso, un plan mensual y semanal de mi vida. Mi otro diario, donde anoto todas mis ideas, es un conjunto de diferentes diseños de todo lo que me gusta. Cada página la lleno con lo que mi creatividad desee. Mi vida está ocupada pero bastante organizada, por lo que mi Journal de ideas es una de las únicas áreas que me permite ser un poco caótica. ¡Me encanta!

the art of
art
the glory
of *expression*
and the
Sunshine
of the light of
letters is *simplicity*

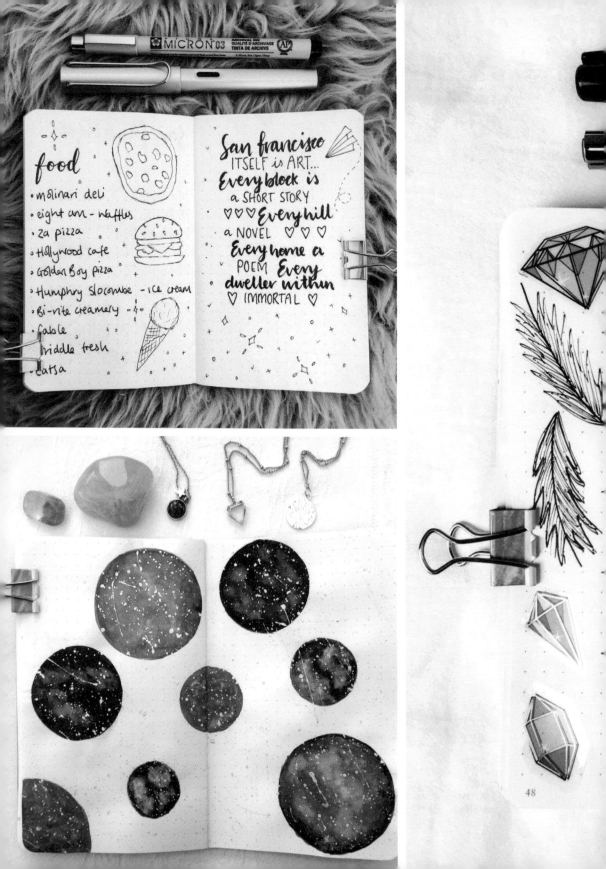

may

m	tues	weds	thurs	fri	sat	sun
	1	2	3	4	5	6
	8	9	10	11	12	13
	15	16	17	18	19	20
	22	23	24	25	26	27
	29	30	31			

Deluxe Journaling

www.deluxejournaling.com
Instagram: @deluxe.journaling
Facebook: Deluxe Journaling

1) What can we find in your journal?
I use my journal for mainly two things. I use it to organize my everyday life and track the most important things. And I use it as a way to be artistic. For many years I didn´t know what to do with my urge for drawing. Now I use that urge to make my journal personal and artistic. So in my journal you can find weekly and monthly spreads, different trackers and a lot of drawings. I draw different motives and patterns as well. Another important thing In my journal is quotes about staying positive, being good to people and remember to live in the moment. That helps me to remember what is important to me and how I want to live my life.

2) What materials do you use to create it?
My journal is mostly black and white which means I use fineliners in many different sizes. I use the Sakura Pigma Micron and Staedtler pigment liner from size 0.05 to size 1.2. To make shades and shadows I use Tombow dual brush pens in different shades of grey. One of my most important tool is my ruler. I love the simplicity of straight lines and I couldn't do that without my ruler.

3) How do you organize the pages to create your journal?
I organise my trackers one month at a time in the end of the previous month. I repeat the most important trackers but try to play with different designs and different ideas . Otherwise I don't plan ahaed. I make my spreads along the way when I need them. My weekly spreads are made the weekend just before I need them. That gives me a possibility to include a lot of different things in my journal each month and it becomes a way to know and remember when I made the different things. To make it less chaotic I have a list of ideas to help me remember what I would like to try out.

1) ¿Qué podemos encontrar en tu journal?
Utilizo mi Journal principalmente para dos cosas. Lo uso para organizar mi vida diaria y hacer un seguimiento de las cosas más importantes. Y también lo uso como una manera de ser artística. Durante muchos años no supe qué hacer con mi necesidad de dibujar. Ahora uso ese impulso para hacer mi diario personal y artístico. Así que en mi diario puedes encontrar detalles semanales y mensuales, diferentes listas de hábitos y muchos dibujos. También dibujo diferentes motivos y patrones. Otra cosa importante de mi Journal son las citas sobre mantenerse positiva, ser buena con las personas y centrarse en vivir el momento. Eso me ayuda a recordar lo que es importante para mí y cómo quiero vivir mi vida.

2) ¿Qué materiales usas para crearlo?
Mi Journal es en su mayoría, blanco y negro, lo que significa que uso bolígrafos de punta fina de tamaños diferentes. Utilizo el bolígrafo Sakura Pigma Micron y Staedtler desde el tamaño 0,05 al 1,2. Para hacer sombras, uso lápices de pincel doble Tombow en diferentes tonos de gris. Una de mis herramientas más importantes es mi regla. Me encanta la simplicidad de las líneas rectas y eso no podría lograrlo sin ella.

3) ¿Cómo organizas las páginas para crear tu journal?
Organizo mis listas de hábitos mensualmente, siempre al final del mes anterior. Repito las listas de hábitos más importantes, pero trato de jugar con diferentes diseños y diferentes ideas. De lo contrario, no planifico con anticipación. Hago mis apartados sobre la marcha cuando los necesito. Mis apartados semanales se hacen el fin de semana justo antes de que los necesite. Eso me da la posibilidad de incluir muchas cosas diferentes en mi diario cada mes, y se convierte en una forma de saber y recordar cuándo hice las diferentes cosas. Para hacerlo menos caótico, tengo una lista de ideas que me ayuda a recordar lo que me gustaría probar.

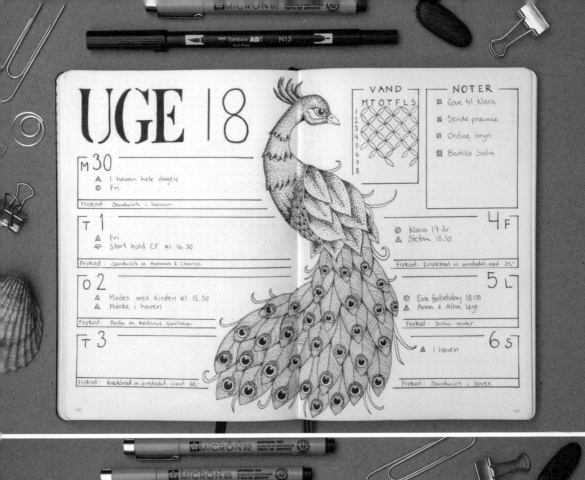

UGE 18

M 30
- ▲ I haven hele dagen
- ◉ Fri

Frokost: Sandwich i haven

T 1
- ▲ Fri
- ⚙ Start hold CF kl. 16.30

Frokost: Sandwich m. Hummus & Chorizo

O 2
- ◉ Mødes med Kirsten kl. 15.30
- ▲ Måske i haven

Frokost: Pasta m. Medisaus, grøntsager

T 3

Frokost: Knækbrød m. æggesalat, ægent 65,-

VAND
M T O T F L S
1
2
3
4
5
6
7
8

NOTER
- ☑ Gave til Klara
- ☑ Sende præmie
- ☑ Ordne bryn
- ☑ Bestille Sushi

4 F
- ◉ Klara 17 år
- ▲ Stefan 13.30

Frokost: Knækbrød m. æggesalat, ægent 24,-

5 L
- ◉ Eva fødselsdag 18.00
- ▲ Anna & Alba lege

Frokost: Sushi - rester

6 S
- ▲ I haven

Frokost: Sandwich i haven

NONE OF US ARE GETTING
OUT OF HERE ALIVE, SO
PLEASE STOP TREATING
YOURSELF LIKE AN AFTER
THOUGT. EAT THE DELICIOUS
FOOD. WALK IN THE SUNSHINE.
JUMP IN THE OCEAN. SAY
THE TRUTH THAT YOU'RE
CARRYING IN YOUR HEART
LIKE HIDDEN TREASURE.
BE SILLY. BE KIND. BE
WEIRD. THERE'S NO TIME FOR
ANYTHING ELSE.

— ANTHONY HOPKINS

HABIT

1 2 3 4 5 6 7 8 9 10 11 12

TRÆNING
CYKLE PÅ ARB
VITAMINER
OMO
TETRA
PROTOPIC
ROZEX
LØBE

VILMAS BUR
TID MED KLARA
TID MED LIVA
TID MED ALBA
TID MED PETER
VENINDETID
SENG

INSTAGRAM
ELOCON

tracker

15 16 17 18 19 20 21 22 23 24 25 26 27 28 29 30 31

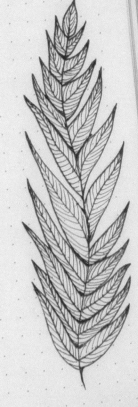

Instagram: @mabujork
Facebook: @mabujork

1) What can we find in your journal?
In my journal you will find task lists, task bars that allocate specific tasks for certain times of the day, tracking logs for habits such as sleep and exercise, a gratitude log for me to reflect and write down what I was thankful for that day, drawings and doodles, and sometimes random journal entries summarizing the highlights of my day. My journal doubles as a productive tool and creative outlet.

2) What materials do you use to create it?
I use a Leuctturm1917 Dotted Notebook in A5 size (Bullet Journal Edition) which is protected by a handmade leather notebook cover by DM Leather Studio as my main journal medium. Although I use a plethora of writing tools, my main arsenal consists of Muji Pens in 0.38mm and 0.25mm sizes, Staedtler Pigment Liner Pens, Zebra Mildliner Highlighters, a clear ruler from Muji, whiteout tape from Muji, Winsor & Newton watercolors, and various stencils from @inkbyjeng to create my bullets and design elements. I carry all my writing tools inside a beautiful gray pencil pouch made by Bellroy.

3) How do you organize the pages to create your journal?
My journal utilizes the basic foundations of the traditional Bullet Journal layout, but also incorporates my own style, creativity, and necessary adjustments in order to adapt to my needs for each day or week. The order of my spreads for each month typically starts with a Monthly Log, Trackers, Gratitude Log, and Daily Logs or Weekly Logs. My monthly log's design is highly dependent on how busy that month is. I create trackers for sleep, steps, and exercise to keep me accountable for important good habits I want to maintain. At the end of each day, I like to reflect on what I was most thankful for and write it down in a gratitude log. I primarily create seven-day weekly spreads to allow for a better visualization for what the week has in store. When I am feeling extra creative, I'll incorporate drawings, doodles, or any design elements to add visual interest to my spreads. When the month finally comes to a close, I log important pages I want to reference at a later date in my Index located at the beginning of my journal.

1) ¿Qué podemos encontrar en tu journal?
En mi Journal encontrarás listas de tareas, listas específicas para ciertos momentos del día, registros de hábitos como el sueño y el ejercicio, un registro de agradecimiento para que reflexione y anote lo que me gustó del día. Dibujos y bocetos, a veces apuntes aleatorios que resumen los aspectos más destacados de mi día. Mi Journal funciona como una herramienta productiva y una salida creativa.

2) ¿Qué materiales usas para crearlo?
Como principal medio para mi Journal, utilizo un cuaderno punteado Leuctturm1917 en tamaño A5 (edición Bullet Journal) que está protegido por una cubierta de cuero hecha a mano por DM Leather Studio. Aunque utilizo una gran cantidad de herramientas de escritura, mi arsenal principal consiste en bolígrafos Muji de 0,38mm y 0,25mm, bolígrafos liner Staedtler, subrayadores Zebra Mildliner, una regla transparente de Muji, cinta tipex de Muji, acuarelas Winsor & Newton, y varias plantillas de @inkbyjeng para crear mis Journals y elementos de diseño. Llevo todas mis herramientas de escritura dentro de un hermoso estuche gris hecho por Bellroy.

3) ¿Cómo organizas las páginas para crear tu journal?
Utilizo los fundamentos básicos del diseño tradicional de un Bullet Journal, pero también incorporo mi propio estilo, creatividad y los ajustes necesarios para adaptar a mis necesidades para cada día o semana. El orden de mis apartados para cada mes generalmente comienza con un registro mensual, listas de hábitos, registro de agradecimiento y registros diarios o semanales. El diseño de mi registro mensual depende en gran medida de lo ocupado que esté ese mes. Creo registros para el sueño, pasos y ejercicios, también para hacerme responsable de los buenos hábitos que deseo mantener. Al final de cada día, me gusta reflexionar sobre lo que más agradecido estoy. Principalmente, creo diferenciales semanales de siete días para permitir una mejor visualización de lo que la semana tiene reservado. Cuando me siento más creativo de la cuenta, incorporo dibujos, bocetos o cualquier elemento de diseño que añada interés visual a mis apartados. Cuando finalmente termina el mes, registro las páginas importantes que quiero consultar en una fecha posterior en mi Índice, ubicado al comienzo de mi Journal.

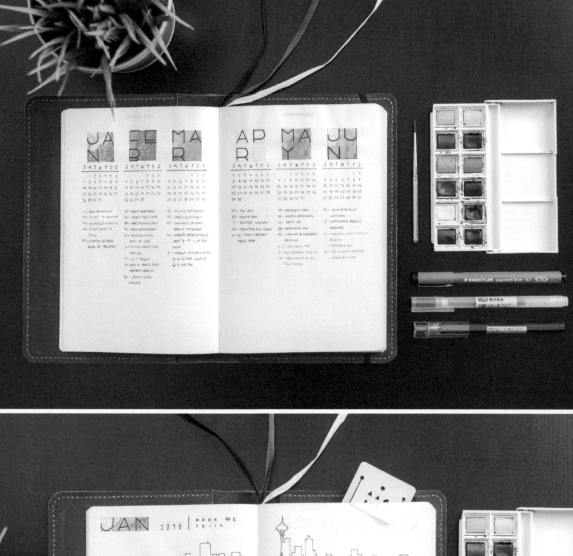

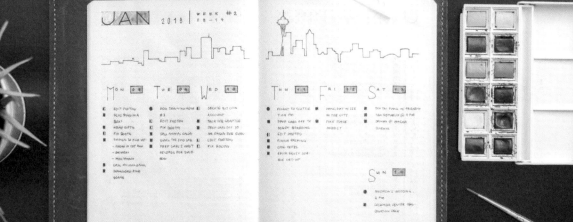

JAN 2018

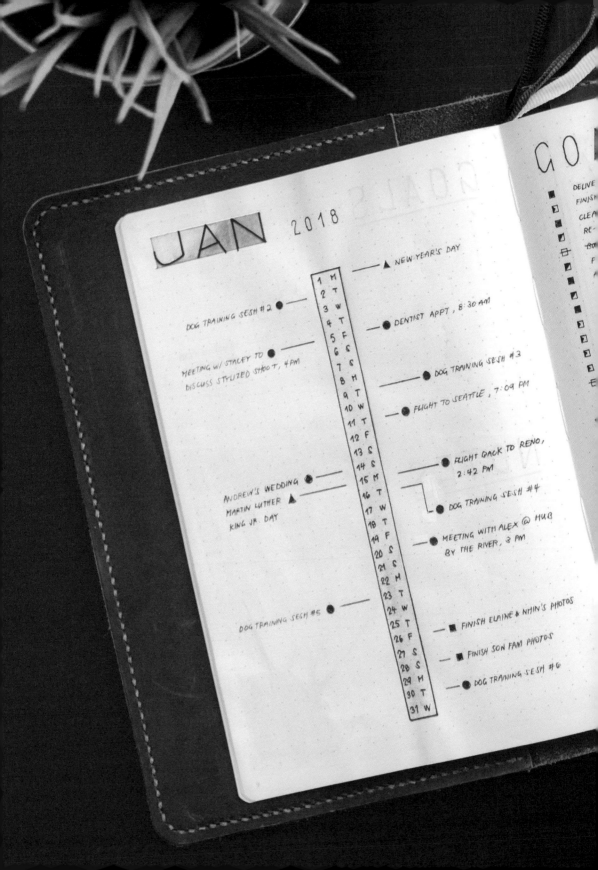

▲ NEW YEAR'S DAY

1 M
2 T
3 W DOG TRAINING SESH #2 ●—— ● DENTIST APPT, 8:30 AM
4 W
5 F
6 F MEETING W/ STACEY TO ●——
7 S DISCUSS STYLIZED SHOOT, 4 PM
8 S ● DOG TRAINING SESH #3
9 M
10 W ● FLIGHT TO SEATTLE, 7:09 PM
11 T
12 F
13 S
14 S ● FLIGHT BACK TO RENO,
15 M ANDREW'S WEDDING ●—— 2:42 PM
16 T MARTIN LUTHER ▲
17 W KING JR. DAY ● DOG TRAINING SESH #4
18 T
19 F ● MEETING WITH ALEX @ HUB
20 S BY THE RIVER, 3 PM
21 S
22 M
23 T
24 W DOG TRAINING SESH #5 ●—— ■ FINISH ELAINE & NHIN'S PHOTOS
25 T
26 F ■ FINISH SON FAM PHOTOS
27 S
28 S
29 M ● DOG TRAINING SESH #6
30 T
31 W

GO
DELIVE
FINISH
CLEA
RE-
BO

S

- R DAVID'S PHOTOG PACKAGE
- RDS
- SET
- OG LOGO
- T ROUTINE
- OHN'S WEDDING TIMELINE
- PHONE PHOTOS
- GUTTER
- S CARDS
- A PINTEREST FOR PHOTOG BUSINESS
- WEBSITE PHOTOS
- ANGE
- CARL TO VET FOR CHECK-UP

TES

- COFFEE UNIQUE TO SEATTLE DURING TRIP
- HOTOG GOALS:
 - EDUCATION
 - SHOOT OFTEN (WITH FILM!)
 - BRANDING
 - BOOK MORE CLIENTS

MUSIC TO DOWNLOAD

- "OUTSIDE" - SAMWISE
- "BEAM" - PETIT BISCUIT
- "LOVE" - SHALLOU

www.dailydots.net
Instagram: @dailydotssk
Facebook: @DailyDotsSK

1) What can we find in your journal?
When you take a trip through my journal you'll find everything from tiny scribbles and sticky notes to hardcore planning of my summer vacation. I don't use digital planning tools anymore so my journal holds my lists and notes - and most importantly it contains my calendar.

2) What materials do you use to create it?
I've been scribbling through a bunch of different journals but the Filofax system works perfectly for me. The possibility for adding and moving around pages is key to effective planning. Along with my beloved Staedtler Pigment liners in size 0.05 to 0.8 and my Tombow Dual Brush pens my journal is the perfect companion.

3) How do you organize the pages to create your journal?
My journal setup is based on what I use most. First comes my calendar with a monthly overview for all major events and then I use a habit tracker to ensure that I spend my time on the right things and get enough exercise. After that come my weekly spreads where I do most of my planning. This setup applies to every month. At the end of my journal you'll find my lists. These include but are not limited to "movies to watch" and "birthday wishes".

1) ¿Qué podemos encontrar en tu journal?
Cuando viajes a través de mi Journal, encontrarás de todo, desde pequeños bocetos y notas adhesivas hasta la planificación de mis vacaciones de verano. No uso herramientas de planificación digital, por eso mi journal contiene mis listas y notas, y lo más importante es que contiene mi calendario.

2) ¿Qué materiales usas para crearlo?
Dibujo en diferentes Journals, pero el sistema Filofax me funciona perfectamente. La posibilidad de dibujar y mover páginas es clave para una planificación efectiva. Junto con mis queridos liners Staedtler en tamaños de 0,05 a 0,8 y mis lápices de pincel doble Tombow, mi journal es el compañero perfecto.

3) ¿Cómo organizas las páginas para crear tu journal?
La configuración de mi Journal se basa en lo que más uso. Primero viene mi calendario con un resumen mensual de todos los eventos importantes y luego uso un registro de hábitos para asegurarme de dedicar tiempo a las cosas necesarias. Después de eso vienen mis apartados semanales donde hago la mayor parte de mi planificación. Esta configuración se aplica a todos los meses. Al final de mi Journal encontrarás mis listas. Estas incluyen "películas para ver" y "listas de deseos".

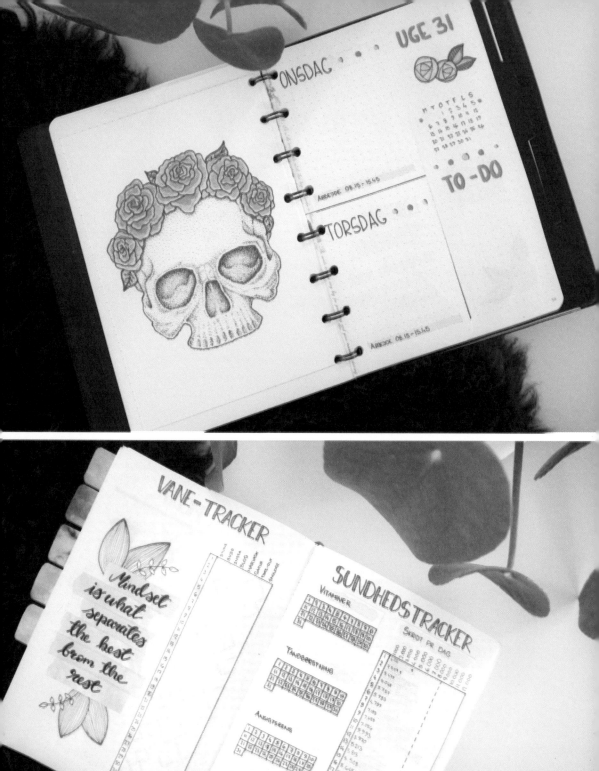

M T O T F L S
 1
2 3 4 5 6 7 8
9 10 11 12 13 14 15
16 17 18 19 20 21 22
23 24 25 26 27 28 29
30 31

REACH FOR THE STARS
EVEN IF YOU HAVE TO STAND
ON A CACTUS

GOALS

- [x] FIND ARBEJDE
- [] PLANLÆG
 SOMMERFERIE

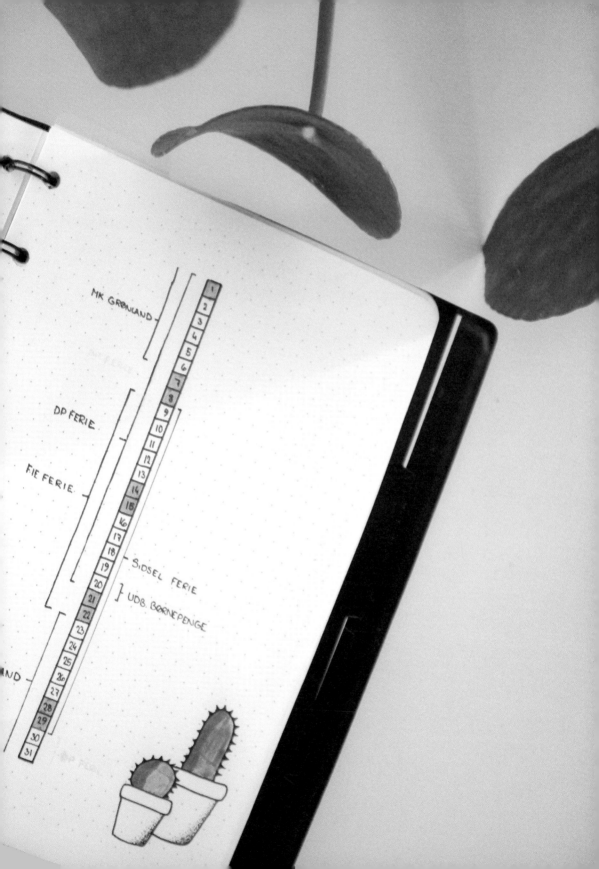

MK GRØNLAND

DP FERIE

FIE FERIE.

SIDSEL FERIE

UDB. BØRNEPENGE

...ND

1
2
3
4
5
6
7
8
9
10
11
12
13
14
15
16
17
18
19
20
21
22
23
24
25
26
27
28
29
30
31

The. Whimsical. Journal

Instagram: @the.whimsical.journal

1) What can we find in your journal?
You can fin calendar pages, both yearly overview, monthly cover pages and weekly layouts. Furthermore I do a lot of drawing and other creative things in it almost every day in some form. The artsy pages makes me want to use my journal everyday because it's not only functional but also pretty.
I also make "to do" lists, packing lists for traveling, info pages about our cat and a list of chores to do in our garden. Basically everything I my daily life to keep me organized.

2) What materials do you use to create it?
My journal is currently a Dingbats* Wildlife. The quality is amazing! A really great book for beginners as well as skilled "journalists".
For my calendar pages I use Sakura Microns size 005 and a Tombow calligraphy pen. For regular writing I use my Kaweco Sport fountain pen. For my creative pages I mostly use watercolors and Sakura Microns 005. Watercolors from Winsor&Newton and Coliro.

3) How do you organize the pages to create your journal?
I always start my journal with a "welcome" page; something creative and with the current year stated. Then comes my "Key". A page stating what symbols I use for different events, holidays, birthdays etc.
After that I have a "year at glance", 2 whole pages for a yearly overlook which also holds birthdays and important puplic holidays.
After that I start the first month in the year: a coverpage and then a weekly spread for each week in that month. My journal always holds a full year. In the back of my journal I keep lists, trackers, ransoms creative outlets and much more.

1) ¿Qué podemos encontrar en tu journal?
Puedes encontrar páginas de calendario, tanto una vista general del año, como páginas de portada mensuales y diseños semanales. Además, en él plasmo muchos dibujos y otras cosas creativas diariamente. Las páginas de Artsy me motivan a usar mi Journal todos los días porque no solo es funcional sino que también es bonito.
También hago listas de tareas pendientes, listas de objetos para viajar, páginas de información sobre nuestro gato y una lista de tareas sobre qué hacer en nuestro jardín.
Básicamente, todo lo que hago en mi vida diaria para mantenerme organizada.

2) ¿Qué materiales usas para crearlo?
Mi tipo de Journal actualmente es un Dingbats* Wildlife. ¡La calidad es increíble! Un libro realmente genial para principiantes así como para "redactores" expertos.
Para las páginas de mi calendario, uso Sakura Microns tamaño 005 y un bolígrafo de caligrafía Tombow. Para la escritura regular utilizo mi pluma estilográfica Kaweco Sport. Para mis páginas creativas utilizo principalmente acuarelas y Sakura Microns 005. Acuarelas de Winsor&Newton y Coliro.

3) ¿Cómo organizas las páginas para crear tu journal?
Siempre comienzo mi Journal con una página de "bienvenida"; algo creativo y con el año en curso indicado.
Luego viene mi "Key", una página que indica qué símbolos utilizo para diferentes eventos, días festivos, cumpleaños, etc.
Después de eso tengo un "registro anual", 2 páginas completas para el registro anual que también alberga cumpleaños y fiestas importantes.
Después de eso, comienzo el primer mes del año: una portada y luego un apartado semanal para cada semana de ese mes. Mi diario siempre tiene un año completo. En la parte posterior de mi diario guardo tareas, listas de hábitos, diseños creativos y mucho más.

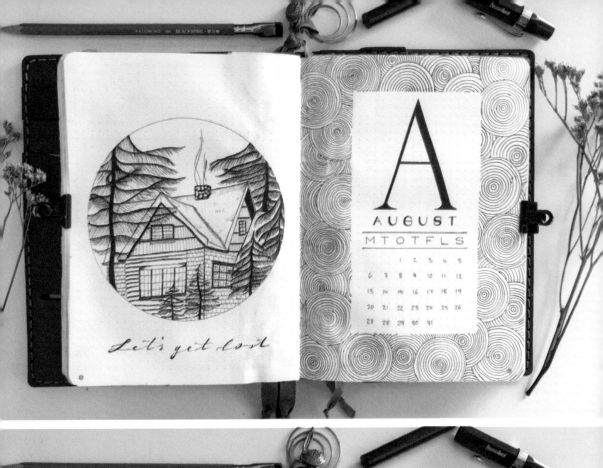

A

AUGUST

M	T	O	T	F	L	S
			1	2	3	4
6	7	8	9	10	11	12
13	14	15	16	17	18	19
20	21	22	23	24	25	26
27	28	29	30	31		

let's get lost

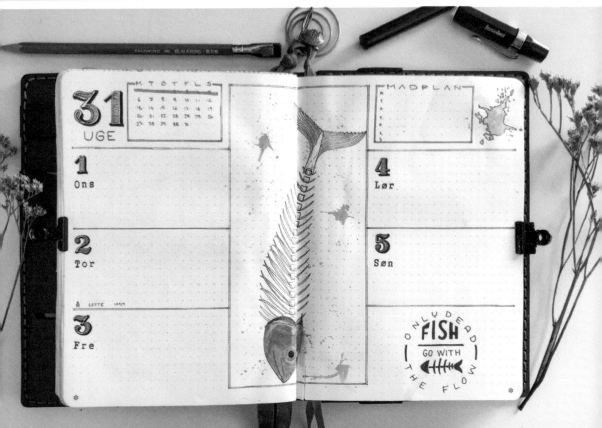

31
UGE

M	T	O	T	F	L	S

MADPLAN

1
Ons

4
Lør

2
Tor

5
Søn

3
Fre

ONLY DEAD FISH GO WITH THE FLO

The perfect cafetiere coffee

Ingredients for 8 cups

 10 dl water

 55 gms coffee

 Coarse grinded

1 Pour 55 gms of coarse grinded coffee into the cafetiere.

2 Pour 10 dl water (95-96°) onto the coffee in the cafetiere.

3 Start a timer. The coffee need to brew for about 3½ minutes. The coffee should be laying on top. 05:30

4 When time's up, you break the surface with a spoon. Stir a couple of times and let the coffee sink to the bottom.

5 Remove the coffee grounds and the white foam on the surface with two spoons. The foam is bitter.

6 Put on the filter and the lid and press down until you reach the bottom. Now, enjoy your coffee!

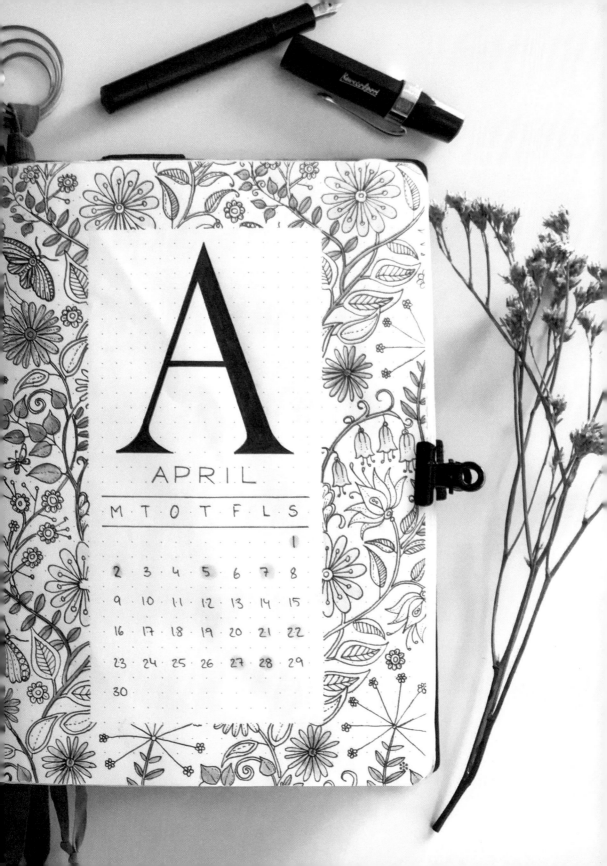

she meets paper

Instagram: @shemeetspaper

1) What can we find in your journal?
More than anything else, I use my bullet journal to collect memories. I love making lists of my current favourites, adding photos using my HP Sprocket printer and creating spreads to record my life. My latest obsession is something called illustrated journaling. It's basically a diary but instead of writing about the things you have done, you draw it instead. It can be anything; from some new plants I bought or the delicious meal of sushi I had to a concert I went to with my sister and best friend.

2) What materials do you use to create it?
My bullet journal is the classical Leuchtturm1917 notebook with an olive coloured cover. I have tried a large variety of fineliners but my absolute favourites for both writing and drawing are the Pigments Liners from Staedtler. For colouring I use the Tombow Dual Brush pens and I've recently started experimenting with watercolours. I am a stationery lover (and hoarder) so I have a lot of washi tapes, stickers, pens etc. But really, all you need is a journal and a pen.

3) How do you organize the pages to create your journal?
I normally start each month with a cover page which reflects the theme I've chosen. The next spread contains a vertical planner for my tasks with a calendar and budget to the side. After that comes my trackers and memory spreads. I normally mark the beginning of each month by putting washi tape around the side of the monthly spread. That way it's easy for me to navigate without having to refer to the index.

1) ¿Qué podemos encontrar en tu journal?
Más que nada, utilizo mi Journal para coleccionar recuerdos. Me encanta hacer listas de favoritos, agregar fotos con mi impresora HP Sprocket y crear apartados para dejar plasmada mi vida. Mi última obsesión es algo que se llama "Journal Ilustrado". Es básicamente un diario, pero en lugar de escribir sobre las cosas que has hecho, las dibujas. Puede ser cualquier cosa: desde algunas plantas nuevas que compré o la deliciosa comida de sushi que comí, hasta un concierto al que fui con mi hermana y mi mejor amiga.

2) ¿Qué materiales usas para crearlo?
Mi Journal es el clásico Leuchtturm1917 con una tapa de color oliva. He probado una gran variedad de rotuladores de punta fina, pero mis favoritos absolutos, tanto para escribir como para dibujar, son los Pigment Liners de Staedtler. Para colorear utilizo los lápices de pincel doble Tombow y recientemente, comencé a experimentar con acuarelas. Soy una amante de la papelería (compulsiva), así que tengo muchas cintas washi, pegatinas, bolígrafos, etc. Pero en realidad, todo lo que necesitas para tu Journal es una libreta y un bolígrafo.

3) ¿Cómo organizas las páginas para crear tu journal?
Normalmente comienzo cada mes con una portada que refleja el tema que he elegido. El siguiente apartado contiene un planificador vertical para mis tareas con un calendario y un presupuesto al lado. Después de eso vienen mis listas de hábitos y para trabajar la memoria. Normalmente marco el comienzo de cada mes colocando cinta washi alrededor del margen mensual. De esa manera es más fácil encontrarlo sin tener que ir al índice.

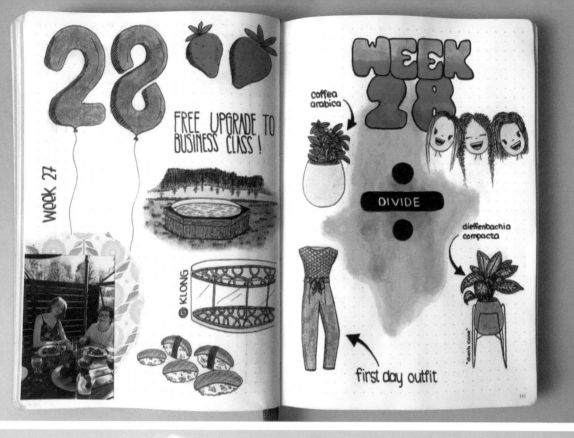

week 27

28

FREE UPGRADE TO BUSINESS CLASS!

© KLONG

WEEK 28

coffea arabica

DIVIDE

dieffenbachia compacta

"dumb cane"

first day outfit

141

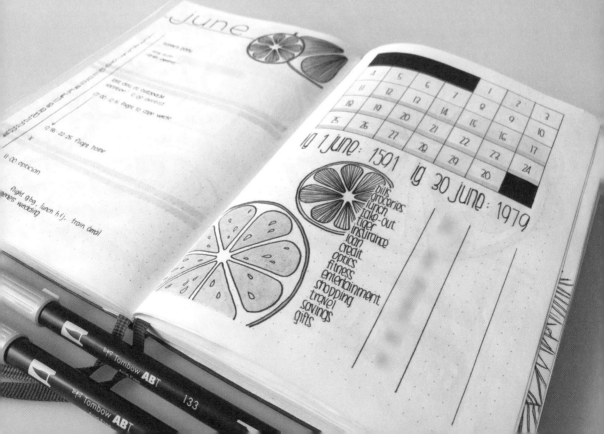

June

ig 1 june: 1501

ig 30 june: 1979

bills
groceries
lunch
take-out
insurance
tiger
loan
credit
optics
fitness
entertainment
shopping
travel
savings
gifts

Tombow ABT

133

Tombow ABT

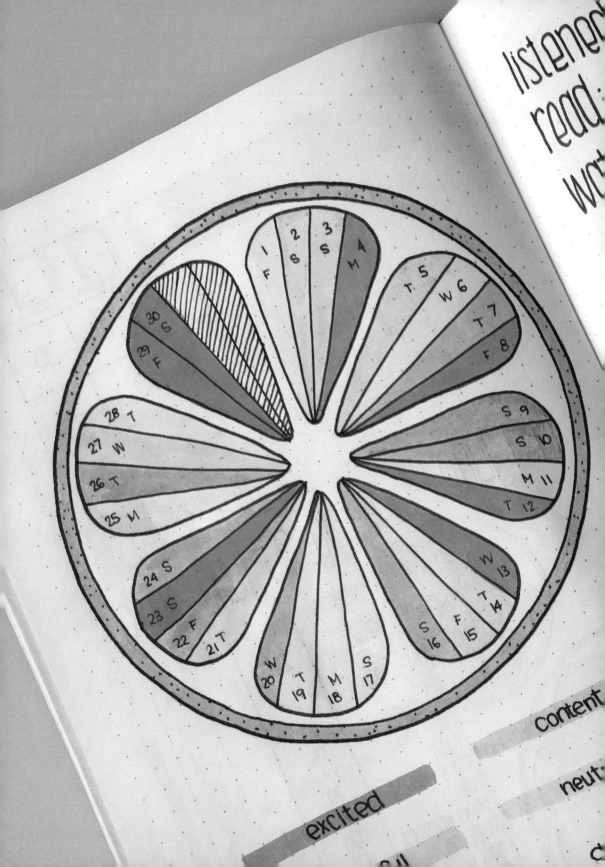

content

neut

excited

mi, shatter me

ed: brooklyn nine-nine
helen toregarden

june

loved: niels, vacation, tigern, cape verde, illustrated journaling, my, parents in-law, detroit: become human, wedding

disliked: long plane rides, dhl

ate: brownie with salted caramel, melia dunas buffé

drank: gin and tonic, vodka/cola, looots of water

celebrated: passing Staatsexamen! sara and eugene

A lukewarm mess

www.alukewarmmess.com
Instagram: @alukewarmmess
Youtube: alukewarmmess
Etsy: alukewarmmess

1) What can we find in your journal?
Pretty much my whole life. I've been battling anxiety and depression for a couple of years and I use my journal to get the thoughts out of my head. I've found that others can relate to what I'm feeling and knowing my journaling can make others feel not so lonely has helped me tremendously, it's given me a purpose. Also, sometimes I'm funny and I make people laugh!

2) What materials do you use to create it?
I use the iPad Pro 12.9 and the Apple Pencil. For my drawings and journaling I use the Procreate app.

3) How do you organize the pages to create your journal?
I don't really organize them, I just save them in a folder in Procreate. I'm not sure what to do with all the pages, maybe someday I print them out and make a book out of them!

1) ¿Qué podemos encontrar en tu journal?
Prácticamente toda mi vida. He luchando contra la ansiedad y la depresión durante un par de años, uso mi Journal para quitarme los malos pensamientos de la cabeza. Descubrir que mis registros pueden hacer que otros no se sientan tan solos me ha ayudado enormemente, me ha dado un propósito. Además, ¡a veces soy graciosa y hago reír a la gente!

2) ¿Qué materiales usas para crearlo?
Uso el iPad Pro 12.9 y el lápiz de Apple. Para mis dibujos y diarios utilizo la aplicación Procreate.

3) ¿Cómo organizas las páginas para crear tu journal?
Realmente no las organizo, simplemente las guardo en una carpeta en Procreate. No estoy segura de qué hacer con todas las páginas, ¡tal vez algún día las imprima y haga un libro con ellas!

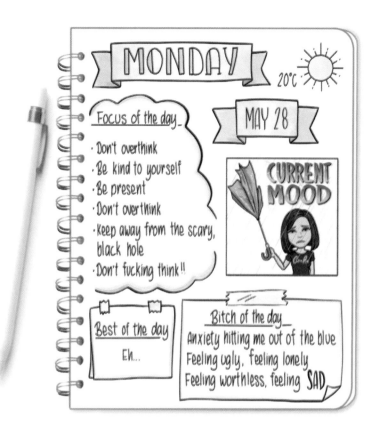

MONDAY

20°C

MAY 28

Focus of the day

- Don't overthink
- Be kind to yourself
- Be present
- Don't overthink
- Keep away from the scary, black hole
- Don't fucking think!!

CURRENT MOOD

Best of the day
Eh...

Bitch of the day
Anxiety hitting me out of the blue
Feeling ugly, feeling lonely
Feeling worthless, feeling **SAD**

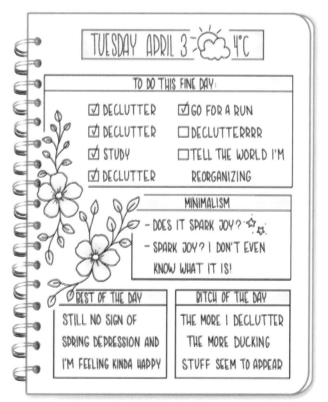

TUESDAY APRIL 3 4°C

TO DO THIS FINE DAY:

- ☑ DECLUTTER
- ☑ DECLUTTER
- ☑ STUDY
- ☑ DECLUTTER
- ☑ GO FOR A RUN
- ☐ DECLUTTERRRR
- ☐ TELL THE WORLD I'M REORGANIZING

MINIMALISM

- DOES IT SPARK JOY? ☆
- SPARK JOY? I DON'T EVEN KNOW WHAT IT IS!

BEST OF THE DAY
STILL NO SIGN OF
SPRING DEPRESSION AND
I'M FEELING KINDA HAPPY

BITCH OF THE DAY
THE MORE I DECLUTTER
THE MORE DUCKING
STUFF SEEM TO APPEAR

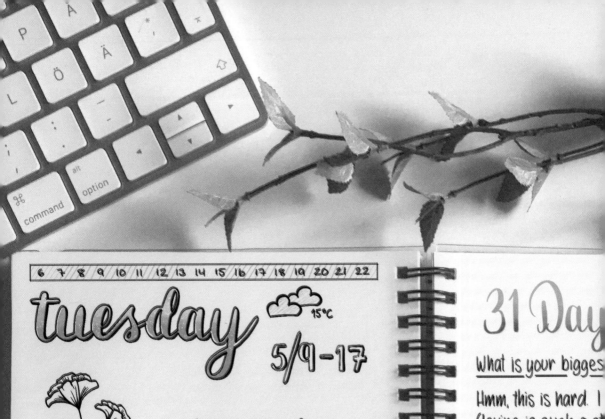

tuesday

15°C

5/9-17

I have questions!

✓ Why is there a dislike button on YouTube? I don't like that! (no pun intended)

✓ Do celebreties make their own bed? Is there a limit how famous they have to be before they have someone doing it for them?

✓ Why can't I move after legday?

My basil is sad

Best of the day

Thanks to my friend I managed to buy a bunch of fancy clothes!

Bitch of the day

Writing about that makes me kinda sad...

31 Day

What is your bigges

Hmm, this is hard. I
(loving is such a st
a couple of years
what I need nowe
what I need inste
limit. By doing so
and bounce back

I see myself as bei
the circumstance
situations I feel c
and I tend to avoid
The fact that I am
me resent myself
starts.

I know this is somet
my biggest strugg
and being vulnera
hurt, you miss out

f self love

gle with loving yourself?

better at liking myself
ord) now than I was
least I give myself
listen to myself and
ushing myself to the
me time to recover
uicker.

rent people depending on
tuation I'm in. In some
worthless and awful
ith all my strength.
these situations makes
ore and a vicious cycle

ed to work on. I guess
ting myself out there
n you're afraid to get
of things...

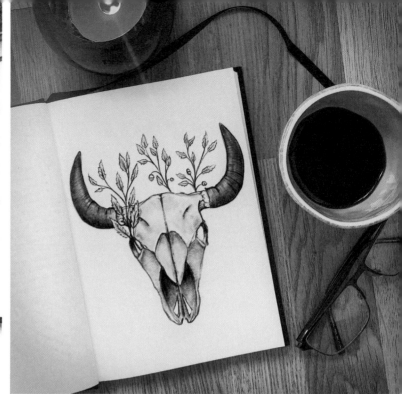

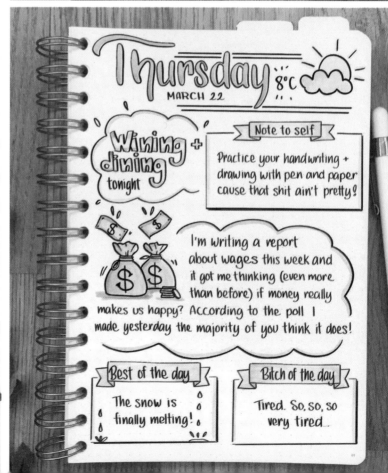

Instagram: @lets.talk.about.bullet
Blog: letstalkaboutbullet.blogspot.com

1) What can we find in your journal?
In my journal you can find my organized life. I own two journals that accompany me in my daily life! In one are cover sheets, monthly trackers and week designs. In my second journal are annual summaries, moon and plant calendars, goals, wish and music lists and also thoughts. Everything in minimalist style with hand drawn plants and geometric shapes. I love this interaction.

2) What materials do you use to create it?
To make geometric shapes are stencils necessary. Sometimes I use a glass or cup to draw a circle. You can use anything if you have the certain creativity. Also I need pencils and pens to refine different strengths - good Mood and my Faber Castell!
For coloring I own a small collection of different brushpens.

3) How do you organize the pages to create your journal?
First - a thought.
This gives me the task drawing something in my journal. I have an „emergency" pencil case with me to sketch ideas everywhere, everytime in my journal.
At home I sit in my crafting room and all what I need is in front of me. At first I trace all with my pencil - erase, draw, erase, draw until I like it. I begin with boxes in that case follows my artwork of flowers and shapes. With my brushpens I bring my pictures to life.

1) ¿Qué podemos encontrar en tu journal?
En mi Journal puedes encontrar mi vida organizada. ¡Soy dueña de dos Journals que me acompañan en mi día a día!
En uno están las portadas, listas de hábitos mensuales y diseños de la semana. En el segundo, hay resúmenes anuales, calendarios lunares y de plantas, objetivos, listas de deseos, música y también pensamientos. Todo en estilo minimalista con plantas dibujadas a mano y formas geométricas. Me encanta esta interacción.

2) ¿Qué materiales usas para crearlo?
Para hacer formas geométricas son necesarias las plantillas. A veces uso un vaso o una taza para dibujar un círculo. Puedes usar cualquier cosa si tienes cierta creatividad. También utilizo lápices y bolígrafos para pulir diferentes puntos fuertes, ¡buen humor y mi Faber Castell!
Para colorear tengo una pequeña colección de diferentes bolígrafos.

3) ¿Cómo organizas las páginas para crear tu journal?
Primero - un pensamiento.
Esto hace que tenga la tarea de dibujar algo. Llevo conmigo una caja de lápices de "emergencia" para dibujar ideas, en todas partes y en cualquier momento.
En casa me siento como en mi taller de manualidades, y todo lo que necesito se encuentra delante de mí. Al principio, trazo todo con mi lápiz: borro, dibujo, borro y dibujo hasta que me guste. Comienzo con recuadros, y continuo mi obra de arte con flores y formas. Con mis rotuladores tipo pincel le doy vida a mis fotos.

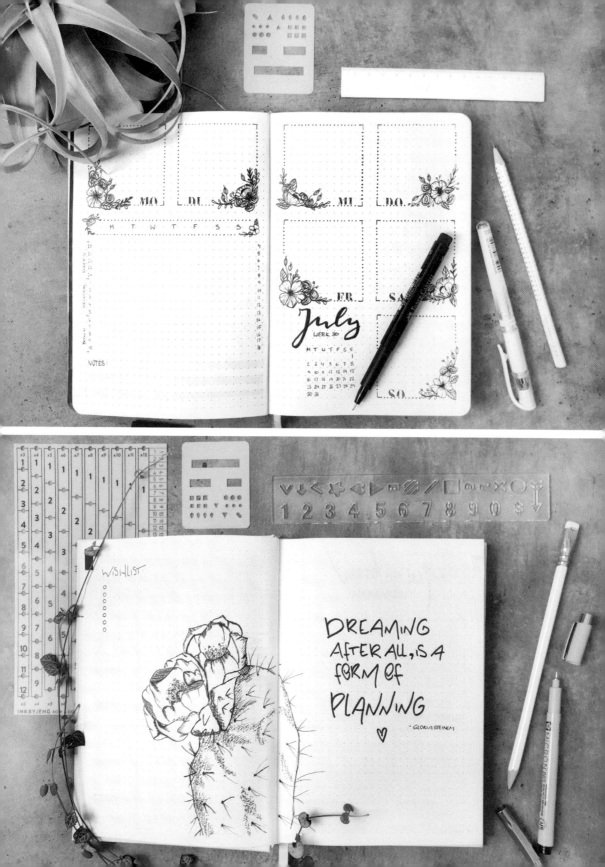

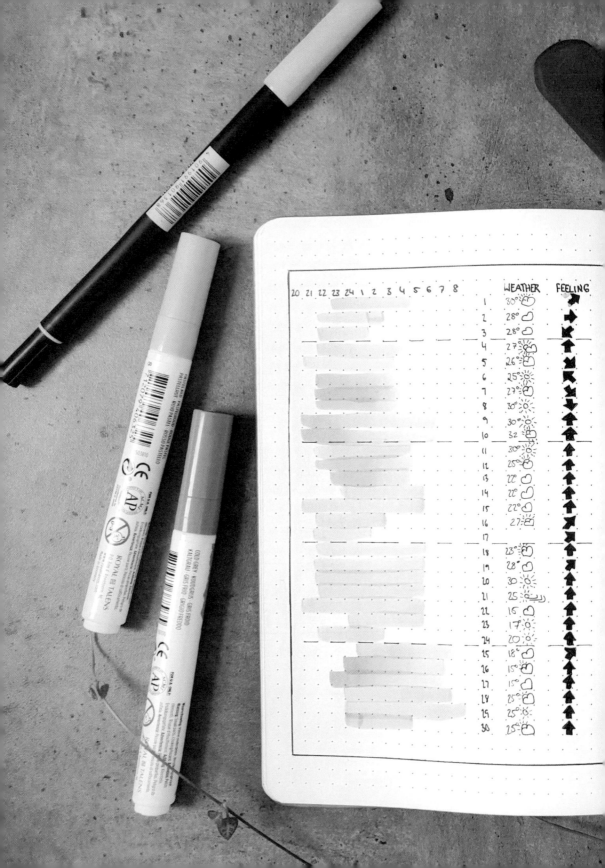

june
2018

STEPS	WORK		🚲 ⏱ 🔒 📷
13K	3-10	1	
13K	■	2	○ ○ ● ●
7K	■	3	○ ○ ○ ○
	■	4	○ ○ ○ ○
11K	■	5	○ ○ ○ ○
12K	■	6	○ ○ ● ○
11K	■	7	● ● ● ●
13K	■	8	○ ○ ● ●
5K	□	9	○ ○ ● ●
4K	□	10	○ ○ ○ ●
12K	■	11	○ ○ ● ●
12K	■	12	○ ○ ○ ○
12K	■	13	○ ○ ○ ○
7K	■	14	○ ○ ○ ○
4K	□	15	○ ○ ● ●
15K	■	16	○ ○ ● ○
	■	17	○ ○ ○ ○
	■	18	● ○ ● ●
	■	19	○ ○ ○ ○
	■	20	● ○ ● ●
	■	21	○ ○ ○ ○
	□	22	○ ○ ○ ○
	□	23	○ ○ ○ ○
	■	24	○ ○ ○ ○
	■	25	○ ○ ○ ○
	■	26	○ ○ ○ ○
	■	27	○ ○ ○ ○
	■	28	○ ○ ○ ○
	□	29	○ ○ ○ ○
	■	30	○ ○ ○ ○

FABER-CASTELL

1 2 3 4 5 6 7 8 9 10 11 12 13 14

@vanessa journals

Instagram: @vanessajournals

1) What can we find in your journal?
I use my bullet journal to organise everything in my brain: from shopping lists, daily tasks, and monthly overviews, to journal entries, collages, and practicing doodles. In order to stay organised every month, I set up several pages before the month begins, which include calendar spreads, habit trackers, and a brain dump. The journal helps me sort through all the things that I need to do, and I find the flexibility and customisation that it allows to be liberating for my frantic mind.

2) What materials do you use to create it?
My personal essentials include a sturdy black gel pen, a fine black brush pen, and a colored brush pen or a marker. I also love using tape, stickers, and images I find online to decorate pages that I think need a little bit more visual interest.

3) How do you organize the pages to create your journal?
I work through and create the pages of my journal in chronological order and try not to skip blank pages. I color-code the pages by month, and I rely heavily on the index built into my notebook. In each month, the spreads I make at the beginning are all grouped together, and anything else I want to put in my journal comes after that, before the next month's spreads appear.

1) ¿Qué podemos encontrar en tu journal?
Uso mi diario para organizar todo lo que tengo en mi cerebro: desde listas de compras, tareas diarias y resúmenes mensuales hasta apuntes cotidianos, collages y la práctica de bocetos. Para mantenerme organizada cada mes, configuro varias páginas antes de que comience el mes. Estas incluyen diferenciales de calendario, listas de hábitos y un volcado de ideas. El Journal me ayuda a analizar todas las cosas que debo hacer, y encuentro la flexibilidad y la personalización que me permiten liberar mi frenética mente.

2) ¿Qué materiales usas para crearlo?
Mis elementos indispensables incluyen un resistente bolígrafo de gel negro, un fino bolígrafo negro y un rotulador de color o un marcador. También me encanta usar cintas, adhesivos e imágenes que encuentro online para decorar páginas que creo que necesitan un poco más de interés visual.

3) ¿Cómo organizas las páginas para crear tu journal?
Trabajo y creo las páginas de mi Journal en orden cronológico y trato de no saltarme páginas en blanco. Codifico por color las páginas por mes y confío en gran medida en el índice incorporado en mi cuaderno. Cada mes creo registros de las diferentes tareas, y las añado en el índice para facilitar su busqueda.

2018
january
15-21
WEEK THREE

monday
- Martin Luther King Jr Day - no school
- □ take instagram photos
- □ edit instagram photos
- place amazon order
15

tuesday
- Martin Luther King Jr. Holiday - no school
- The Greatest Showman (UTC) @ 1:05 pm
16

wednesday
- A day ()
- 6:00-7:30 pm - rehearsal (history)
17

thursday
- B day ()
- (p.5)
 19 - 3:30 pm

friday
- C day ()
- (history,) 19

saturday
-
 rehearsal - 3:15
20

sunday
- violin lesson - 2:15
21

CAN
star
AT
ocea
eye

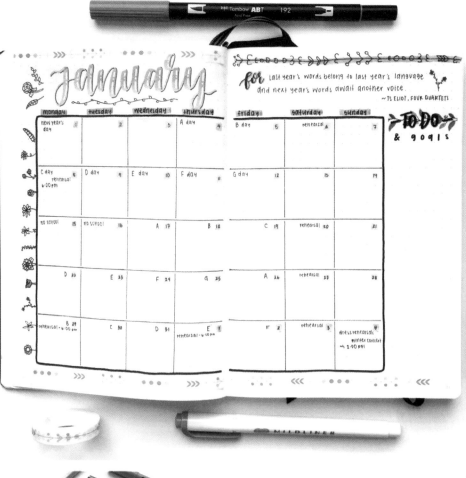

Juian Keith Maquiraya

Instagram: @juian.k
YouTube: Juian Dot K

1) What can we find in your journal?
Growing up, I was always thought on how to be organized. When I first discovered bullet journaling back in 2016, I thought that it was a great way to furthermore enhance my organization skills. I believe that every individual who uses bullet journal has a system that works for them. What system a single bullet journalist use might not apply to others. As you go through with bullet journal every day you will discover systems that will work on you best. I always like drawing and adding lots of colours on my spreads. In a way, the bullet journal system that I use now, is more geared towards my creative side because my journal is used as a sketchbook and as a journal itself. I wanted to have a file that I can look back to, to be able to see my art journey and also my journaling throughout the years in one single system. Some of the arts that I put on my bullet journal pages are my doodles, watercolour arts, and my calligraphies.

2) What materials do you use to create it?
When starting out in bullet journal, all you need is a pen and a notebook. You can always try to learn the system of bullet journaling so that you can find out what you like and what works best for you. And after that, you can add whatever you like. The notebook that I always use for my journal is a dotted notebook. It doesn't matter what brand really. Why dotted journal? The dots is a major help in measuring where my lines should go if I decide to section something. Since I draw a lot on my journal, other materials I use are fine liners, color pens and watercolors. For my calligraphies, I always use a brush pen. Other materials that are a must for me are mechanical pencil, eraser and a ruler.

3) How do you organize the pages to create your journal?
The most important thing that I use so that my journal to be organized are KEYS. These are individual legends for you to determine if you have to do a task, a doctor's appointment, an event or even if you are just writing random notes. Once you start writing everything down, these things can get mixed up together making it disorganized. Having a key system is imperative in bullet journaling. To get my journal more organized, I use colour coding for every month. I designate a monthly theme for my journal, and I try to stick on the theme chosen for the duration of the whole month. Doing so, it does not only make my journal more organized, but I also think that it makes it more appealing to the eyes.

1) ¿Qué podemos encontrar en tu journal?
A medida que crecía, siempre pensé en cómo organizarme. Cuando descubrí el diario Bullet en 2016, pensé que era una excelente manera de mejorar mis habilidades de organización. Creo que cada persona que usa un diario ha de tener su propio estilo. El sistema que utilicen algunos no tendría por qué aplicarse a otros. Siempre que escribas a diario, descubrirás los sistemas que mejor te funcionan. Siempre me gusta dibujar y darle mucho colorido a mis páginas. En cierto modo, el sistema de diario que utilizo ahora está más orientado hacia mi lado creativo, ya que lo uso como cuaderno de bocetos y como diario en sí mismo. Quería tener un archivo en el que pudiese siempre consultar, poder ver mi viaje artístico y también mi diario a lo largo de los años con un solo sistema. Algunas de las artes que coloco en las páginas de mis diarios son mis dibujos, mis acuarelas y mis caligrafías.

2) ¿Qué materiales usas para crearlo?
Al comenzar con un nuevo diario, lo único que necesitas es un bolígrafo y un cuaderno. Siempre puedes tratar de aprender tu propio sistema de manera que consigas averiguar qué te gusta y qué te funciona mejor. Y, después de eso, puedes agregar lo que quieras. El cuaderno que siempre uso para mi diario es un cuaderno punteado. No importa qué marca realmente. ¿Por qué punteado? Los puntos son una gran ayuda para medir dónde deben ir mis líneas si decido separar. Como me gusta mucho dibujar, otros materiales que utilizo son delineadores finos, colores y acuarelas. Para mis caligrafías, siempre uso un bolígrafo-pincel. Otros materiales que son imprescindibles para mí son un portaminas, un borrador y una regla.

3) ¿Cómo organizas las páginas para crear tu journal?
Lo más importante que utilizo para organizar mi diario son CLAVES. Estas son leyendas individuales para determinar si se tiene que hacer una tarea, si se tiene una cita con el médico, un evento o incluso si solo se están escribiendo notas al azar. Una vez que comienzas a escribir, estas cosas pueden mezclarse y desorganizarse. Tener un sistema clave es imprescindible. Para que mi diario esté más organizado, utilizo códigos de colores para cada mes. Designo un tema mensual para mi diario, e intento mantener el tema elegido durante todo el mes. Al hacerlo, no sólo consigo que mi diario sea más organizado, sino que también creo que lo hace visualmente más atractivo.

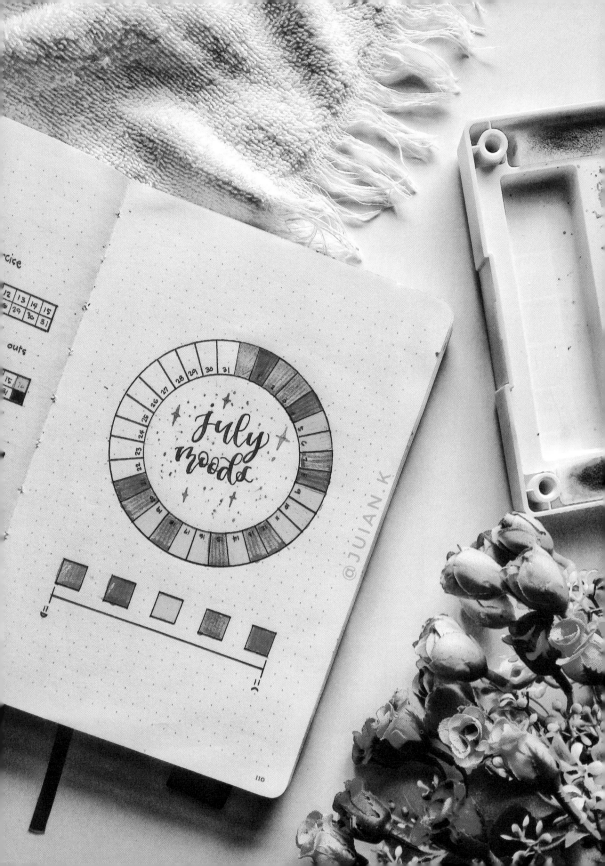

july moods

@JUIAN.K

110

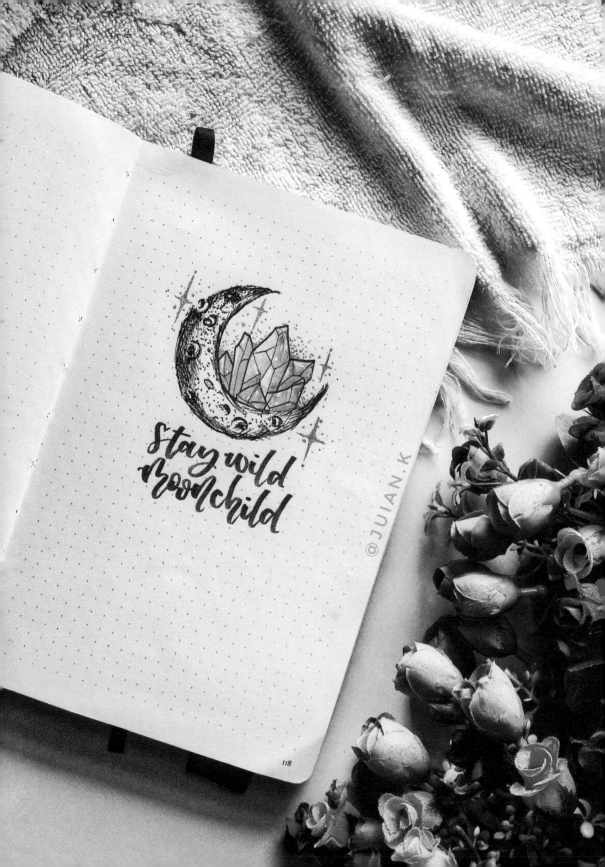

Stay wild
moonchild

118

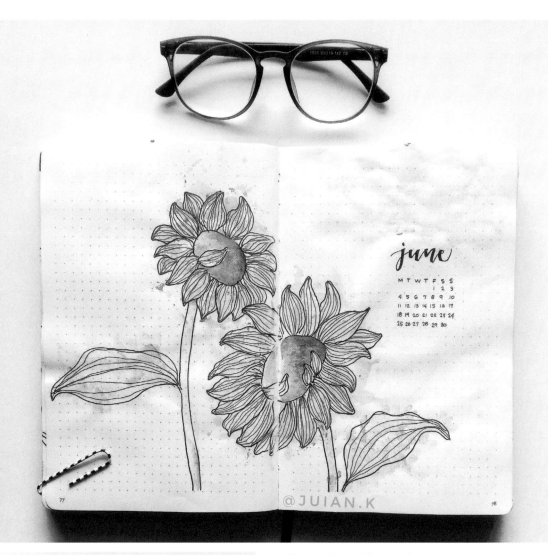

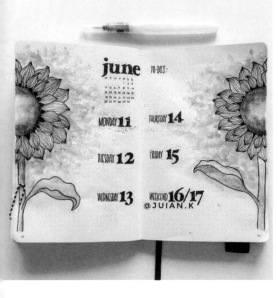

Fenke

Instagram: @fenkesjournal
Etsy: Fenkesjournal

1) What can we find in your journal?
I use my journal for both planning and a creative outlet. A little over a year ago, I couldn't find the perfect planner to fit my needs. Then I stumbled upon the bullet journal system. I can adjust how I set up my weekly layouts to my needs. I love how my journal thereby rekindled my love for drawing and being creative. Drawing used to be my biggest hobby as a kid, but I hadn't drawn in years. My journal pushes me to keep drawing and trying new things. So my journal is a combination of monthly and weekly overviews, doodles, drawings, watercolors and handlettering pages.

2) What materials do you use to create it?
When I started journalling I started out simple, but everytime I feel comfortable with the materials I want to try out different materials again. I use fineliners to draw, small and big brush pens, markers and watercolours. Sometimes I use washi tape and stickers, but most of the time I like to doodle things myself. For someone starting out I'd say a pack of water resistant fineliners and some colored markers are the essentials. It does not have to be expensive either, the Crayola supertips might be my favourite markers and I bought a pack of 100 for only 14,99 EUR. Recently, I started to try out digital drawing on an iPad.

3) How do you organize the pages to create your journal?
My favourite part about bullet journalling is how versatile it, it can be anything you want. When I flip through my first bullet journal I can see everything I created at that time in one place. I like to just flip to the next empty page and start creating. I switch up how I set up my weekly spreads too, to fit my needs as well as to keep it fun.
I usually start every month with a montly cover and monthly overview page, after that everything is in the order I created it. So my weekly overviews are alternated by doodle pages and handlettering pages. This way I don't have to think about it too much, and this works perfect for me.

1) ¿Qué podemos encontrar en tu journal?
Uso mi Journal tanto para la planificación como para la creatividad. Hace poco más de un año, no pude encontrar la agenda perfecta para satisfacer mis necesidades. Entonces me topé con el sistema del Bullet Journal. Así, puedo encajar cómo configuro mis diseños semanales. Me encanta cómo mi Journal me hace revivir mi amor por el dibujo y la creatividad. El dibujo solía ser mi pasatiempo más grande cuando era niña, pero no había dibujado en años. Mi Journal me empuja a seguir dibujando y probando cosas nuevas. Así que mi diario es una combinación de resúmenes mensuales y semanales, bocetos, dibujos, acuarelas y páginas de Handlettering.

2) ¿Qué materiales usas para crearlo?
Cuando comencé a escribir en mi Journal lo hice de forma simple, me gusta probar nuevos materiales, así puedo descubrir diferentes acabados. Utilizo los delineadores para dibujar, pinceles pequeños y grandes, marcadores y acuarelas. A veces uso cintas washi y pegatinas, pero la mayoría de las veces me gusta dibujar cosas por mí misma. Para alguien que comienza, diría que es esencial un paquete de liners de punta fina resistentes al agua y algunos marcadores de colores. Tampoco tienen que ser caros, los supertips de Crayola son probablemente mis marcadores favoritos, compré un paquete de 100 por solo 14,99 €. Recientemente, comencé con el dibujo digital en un iPad.

3) ¿Cómo organizas las páginas para crear tu journal?
Mi parte favorita a la hora de hacer un diario es su versatilidad; puede ser lo que tú quieras que sea. Cuando miro mi primer diario, puedo ver todo lo que creé en ese momento en un solo lugar. Sencillamente, me gusta pasar a la siguiente página vacía y comenzar a crear. También cambio la forma en que configuro mis registros semanales para que se ajusten a mis necesidades y para que sea divertido.
Por lo general, comienzo cada mes con una portada mensual y una página de resumen mensual; a partir de ahí, todo irá en el orden según yo lo vaya creando. Así, mis vistas semanales se alternan con páginas de bocetos y páginas en las que dibujo letras. De esta manera, no tengo que pensar demasiado, y este sistema me funciona perfectamente.

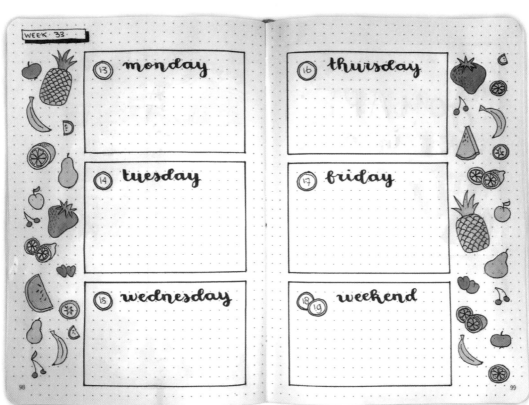

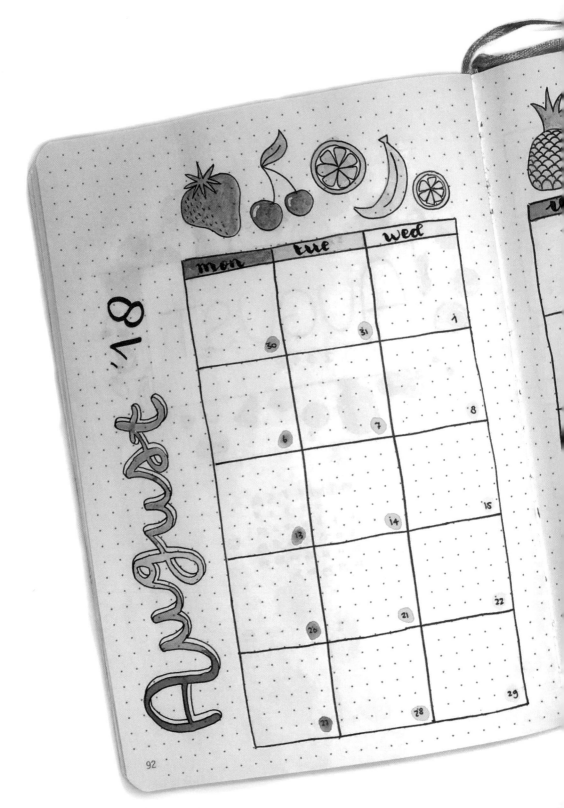

August '18.

mon	tue	wed
30	31	1
6	7	8
13	14	15
20	21	22
27	28	29

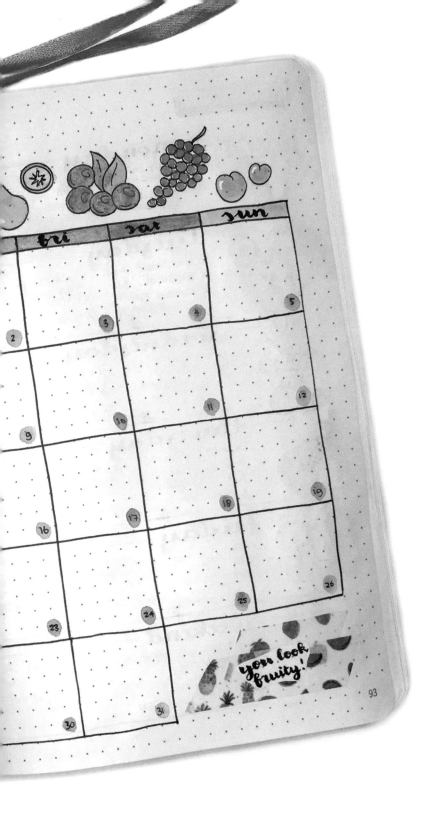

fri | sat | sun

	3	4	5
2			
9	10	11	12
16	17	18	19
23	24	25	26
30	31		

you look fruity!

Instagram: @wood_bujo
Twitter: @VirGraceWood

1) What can we find in your journal?
In my journal you can find my organisation for every month. I draw spreads to track my habits (such as my sleep, how many times I take a shower, if I drink enough etc.) and weekly spreads for my commitments and my plans. Every month has a theme which means that every month has a particular decoration, and it's here that I use my art and my creativity to make my journal colorful and unique!

2) What materials do you use to create it?
I use brush pens to handlettering, I also have fineliners to draw my spreads and a lot of gel pens, washi tapes, pencils and mildliners to decorate the pages. Sometimes when I want to create something more sophisticated I use my watercolours and my tempera painting. I really like buying new art supplies to use in my journal!

3) How do you organize the pages to create your journal?
I'm pretty insecure when it comes to drawing so I always draw the spreads with a pencil before tracing over them with a fineliner. The beautiful thing about bullet journals is that you can decide how you want to organize everything and you can always try something new or stop doing spreads that you can't find useful. I always do a cover page of the month, a calendar, then some pages for my trackers like my sleep tracker, my habit tracker, my expense tracker; something that you'll always find in my journal is a page where I write all the beautiful and happy things that happened to me during the month. It's a page full of positivity!

1) ¿Qué podemos encontrar en tu journal?
Mi Journal se organiza por meses. Dibujo los apartados para rastrear mis hábitos (horas de sueño, cuántas veces me ducho, si bebo lo suficiente, etc.) y los registros semanales para mis compromisos y mis planes. Cada mes tiene un tema, lo que significa que cada mes tiene una decoración particular, ¡es aquí donde uso mi arte y mi creatividad para hacer que mi Journal sea colorido y único!

2) ¿Qué materiales usas para crearlo?
Utilizo rotuladores tipo pincel para el Handlettering, también tengo delineadores para dibujar mis apartados y muchos bolígrafos de gel, cintas washi, lápices y rotuladores midliner para decorar las páginas. A veces, cuando quiero crear algo más sofisticado, uso mis acuarelas y mis témperas. ¡Me gusta comprar nuevos materiales para los diseños de mi Journal!

3) ¿Cómo organizas las páginas para crear tu journal?
Soy bastante insegura cuando se trata de dibujar, así que siempre dibujo primero a lápiz antes de trazarlos con un liner de punta fina. Lo bonito de los Bullet Journals es que puedes decidir cómo quieres organizar todo y siempre puedes probar algo nuevo o dejar de crear apartados que no encuentres útiles. Siempre diseño una portada del mes, un calendario, luego algunas páginas para mis listas de hábitos como un cuadro de horas de sueño, mi registro de hábitos, mis gastos; algo que siempre encontrarás en mi Journal es una página donde escribo todas las cosas hermosas y felices que me sucedieron durante el mes. ¡Es una página llena de positividad!

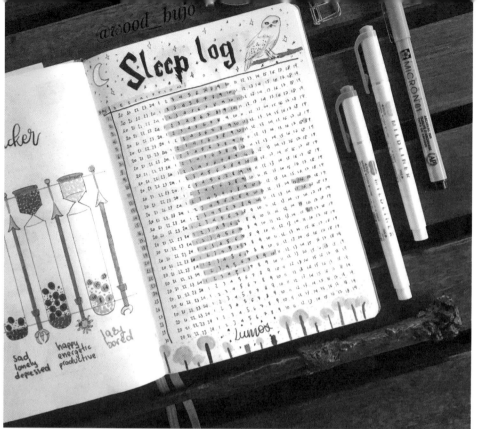

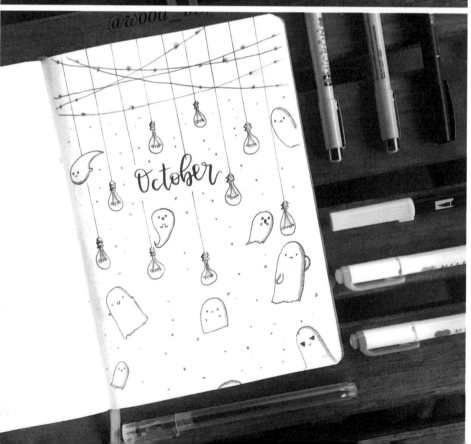

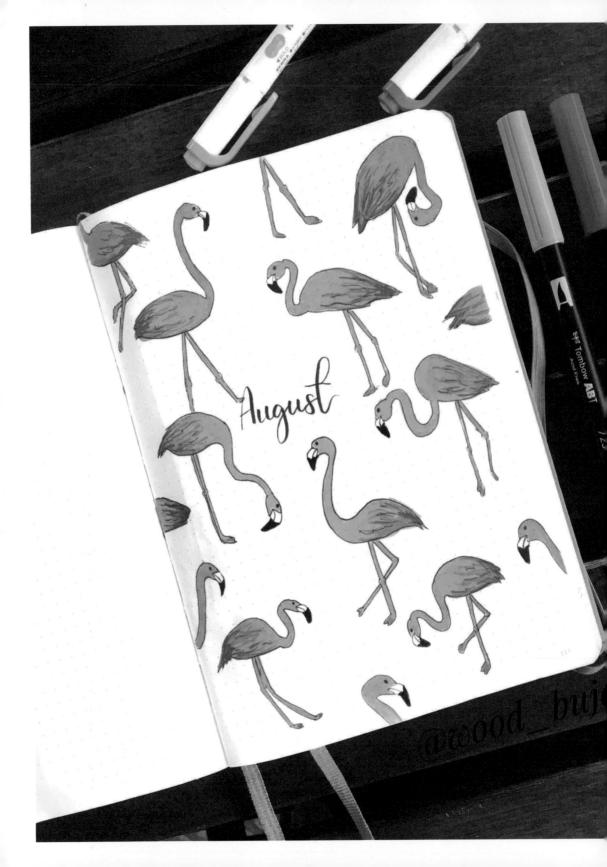

August

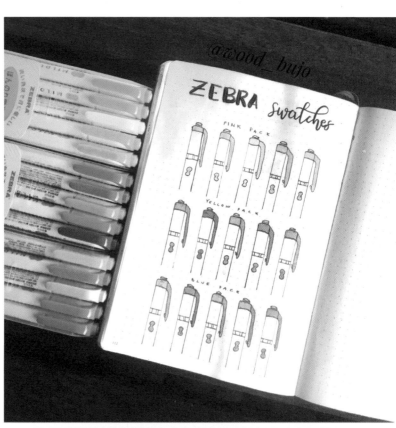

@wood_bujo

ZEBRA swatches

PINK PACK

YELLOW PACK

BLUE PACK

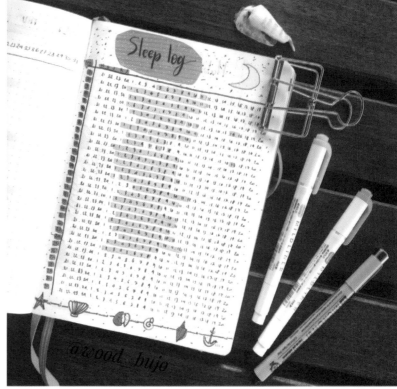

Sleep log

Instagram: @mashaplans
Pinterest: @mashaplans
Facebook: @mashaplans

1) What can we find in your journal?
Actually, I have a few journals. My main journal is for my goals, personal development and daily planning. Here you'll see my habit and goal trackers, daily and weekly spreads, as well as to do lists.
My second journal is dedicated to my blog. Here I have all the statistics of the blog, my content plan, ideas and all the blogging related research.
My third journal is what I call "journal for fun". Here I gather all my collections - long lists of books I've read, movies I've watched and such. Here I also do my doodling and create different non planning pages.

2) What materials do you use to create it?
I have quite a collection of stationary and I try to use it all. There are a few things I use all the time, and these are: Sakura Pigma Micron fineliners (I use them for all kinds of drawing in my journal) and Muji ballpoint pen (perfect companion for my everyday writing).
As for colors, my top favorite are Tombow Dual Brush Pens, specially the pastel set, and Zebra Mildliner Highlighters.
And of course the notebooks I use for my journaling: Nuuna and Rhodium Mines dot grid notebooks.

3) How do you organize the pages to create your journal?
I use Bullet Journal system for all my journals, so it's linear approach. I create pages as I go. What helped me to keep it well organized is first - having an index and numbered pages. That way all the information is easy to find.
Second - I keep my information organized by using several journals. I divided all my journaling into three parts: planning, blogging and doodling. And now each part has its own journal. That way every journal is well organized about just one topic.

1) ¿Qué podemos encontrar en tu journal?
En realidad, tengo unos cuantos Journals. Mi Journal principal es para mis objetivos, desarrollo personal y planificación diaria. Aquí verás mis listas de hábitos y metas, los apartados diarios y semanales, así como las listas de tareas pendientes.
Mi segundo Journal está dedicado a mi blog. Aquí tengo todas las estadísticas del blog, mi plan de contenido, ideas y toda la investigación relacionada con él.
Mi tercer Journal es lo que llamo "diario por diversión". Aquí reúno todas mis colecciones: largas listas de libros que he leído, películas que he visto y demás. Aquí también hago mis bocetos y creo diferentes páginas sin planificación.

2) ¿Qué materiales usas para crearlo?
Tengo una colección bastante grande de papelería y trato de usarlo todo. Hay algunas cosas que uso todo el tiempo: rotuladores de punta fina Sakura Pigma Micron (los uso para todo tipo de dibujos) y el bolígrafo Muji (el compañero perfecto para mi Lettering).
En cuanto a los colores, mis favoritos son los lápices de pincel doble Tombow, especialmente el juego en colores pastel, y los subrayadores Zebra Mildliner.
Y, por supuesto, los cuadernos que utilizo para mi Journal: cuadriculados y punteados Nuuna y Rhodium Mines.

3) ¿Cómo organizas las páginas para crear tu journal?
Utilizo el sistema Bullet Journal para todos mis diarios, por lo que es un enfoque lineal. Creo páginas a medida que avanzo. Lo que me ayuda a mantenerlo bien organizado es, primeramente: tener un índice y páginas numeradas. De esta manera, toda la información es fácil de encontrar. En segundo lugar: Mantengo mi información organizada mediante el uso de varios Journals. Lo divido en tres partes: planificación, blogs y bocetos. Así tengo un Journal para cada estilo, de esta manera, cada Journal está bien organizado sobre un solo tema.

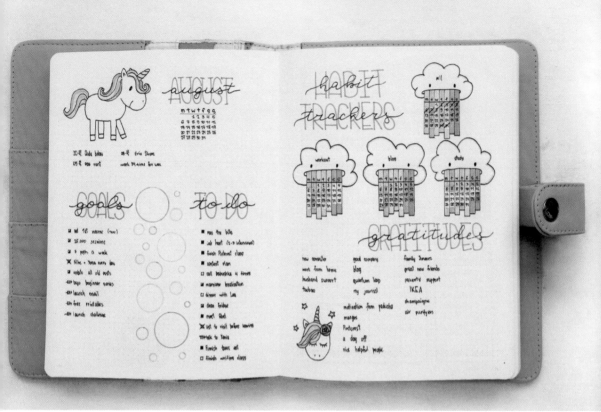

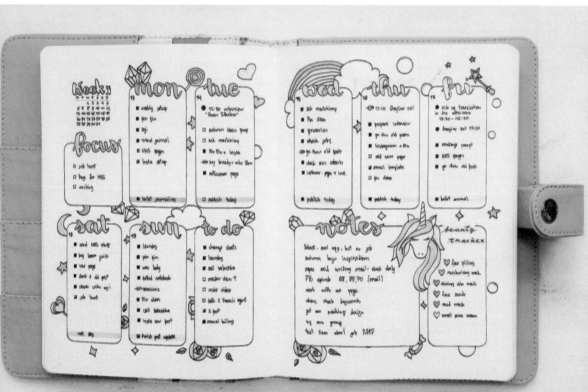

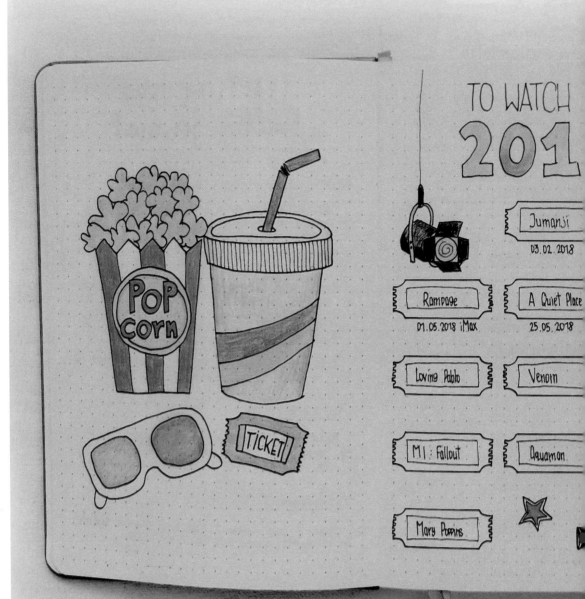

TO WATCH
201

Jumanji
03.02.2018

Rampage
01.05.2018 iMax

A Quiet Place
25.05.2018

Loving Pablo

Venom

M1 : Fallout

Aquaman

Mary Poppins

Ready Player One
05.04.2018 iMax

Jurassic World 2
16.06.2018 iMax

Deadpool 2

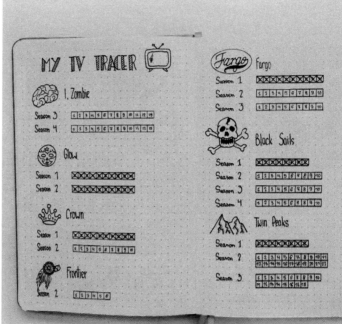

MY TV TRACER

1. Zombie

Season 3 | 1 2 3 4 5 6 7 8 9 10 11 12 13
Season 4 | 1 2 3 4 5 6 7 8 9 10 11 12 13

Glow

Season 1 | ✕✕✕✕✕✕✕✕✕✕
Season 2 | ✕✕✕✕✕✕✕✕✕✕

Crown

Season 1 | ✕✕✕✕✕✕✕✕✕✕
Season 2 | 1 2 3 4 5 6 7 8 9 10

Frontier

Season 2 | 1 2 3 4 5 6

Fargo

Season 1 | ✕✕✕✕✕✕✕✕✕✕
Season 2 | 1 2 3 4 5 6 7 8 9 10
Season 3 | 1 2 3 4 5 6 7 8 9 10

Black Sails

Season 1 | ✕✕✕✕✕✕✕✕✕✕
Season 2 | 1 2 3 4 5 6 7 8 9 10
Season 3 | 1 2 3 4 5 6 7 8 9 10
Season 4 | 1 2 3 4 5 6 7 8 9 10

Twin Peaks

Season 1 | ✕✕✕✕✕✕✕✕✕✕
Season 2 | 1 2 3 4 5 6 7 8 9 10 11 12 13 14 15 16 17 18 19 20 21 22
Season 3 | 1 2 3 4 5 6 7 8 9 10 11 12 13 14 15 16 17 18

UNICORNS I LOVE THEM

studywithmaggie

Instagram: @studywithmaggie
Youtube: @studywithmaggie

1) What can we find in your journal?
My journal is a mix of both a day to day planner and a travel journal. You can find all sorts of things in my journal from old tickets to events to musings about my day. I like to keep my journal as flexible as possible, allowing it to be able to adapt to any sudden changes in plan or if things don't pan out the way I expected them to because it's impossible to plan everything down to the last minute! I mostly use it as a way to keep track of my schoolwork and chores both as a reminder to finish my tasks and also a motivation to get as much done in a day as possible so that I can look back and be proud of how I've spent my time that day.

2) What materials do you use to create it?
I make most of my spreads with only a few tools like a black fountain pen and some markers (my favourite are the Zebra Mildliners!). I also like to use some calligraphy pens to create nice headers and fonts to add a little contrast and decoration to my journal. Another material I love to use is stickers! I own my own sticker shop called itspaperco and create both functional and decorative stickers to use in my journal. I think stickers can both save time when you're in a rush and also add a little colour and dimension that you can't always get with just pens alone.

3) How do you organize the pages to create your journal?
My double page spreads normally span a time of about a week, which gives an adequate amount of space to list around 8-10 tasks a day. If I know my days are extremely busy (which is mostly the weekends for me and any days I have off of university), then I tend to use one whole page for one day and split each task into the time I should finish it by in order to get everything done. Once I've decided how much space I need for the next few days to plan then I go ahead and think about the colour scheme or if I'd like to create a more functional or scrapbook style spread.

1) ¿Qué podemos encontrar en tu journal?
Es una mezcla de planificador y diario de viaje. Puedes encontrar todo tipo de cosas, desde entradas antiguas hasta eventos y reflexiones sobre mi día. Me gusta mantenerlo lo más flexible posible, permitiéndole que se adapte a cualquier cambio repentino, o si las cosas no salen como yo lo esperaba, ya que ¡es imposible planificar todo hasta el último minuto! Principalmente, lo uso como una forma de hacer un seguimiento de mis tareas, como un recordatorio para terminarlas y también como una motivación para hacer todo lo que pueda abarcar en un día; y así, poder mirar hacia atrás y estar orgullosa de cómo he invertido mi tiempo ese día.

2) ¿Qué materiales usas para crearlo?
Hago la mayoría de mis apartados con solo unas pocas herramientas, una pluma estilográfica negra y algunos marcadores ¡mis favoritos son los Zebra Mildliners! También me gusta usar algunos bolígrafos de caligrafía para crear bonitos encabezados y fuentes, y agregar un poco de contraste y decoración a mi Journal. ¡Otro material que me encanta usar son las pegatinas! Tengo mi propia tienda de adhesivos llamada Itspaperco y creo adhesivos funcionales y decorativos. Creo que las pegatinas pueden ahorrar tiempo cuando tienes prisa y también añaden un poco de color y dimensión, lo cual no siempre se puede obtener usando solamente bolígrafos.

3) ¿Cómo organizas las páginas para crear tu journal?
Mis apartados a doble página normalmente abarcan una semana, lo que da una cantidad adecuada de espacio para enumerar de 8 a 10 tareas por día. Si sé que mis días están extremadamente ocupados (principalmente los fines de semana y los días en los que no tengo universidad), tiendo a usar una página entera por día y divido cada tarea en el tiempo en que debo terminarla para dejarlo todo hecho. Una vez que he decidido cuánto espacio necesito para planificar los próximos días, sigo adelante y pienso en el esquema de color o en si me gustaría crear una distribución más funcional o con un estilo de bloc de notas.

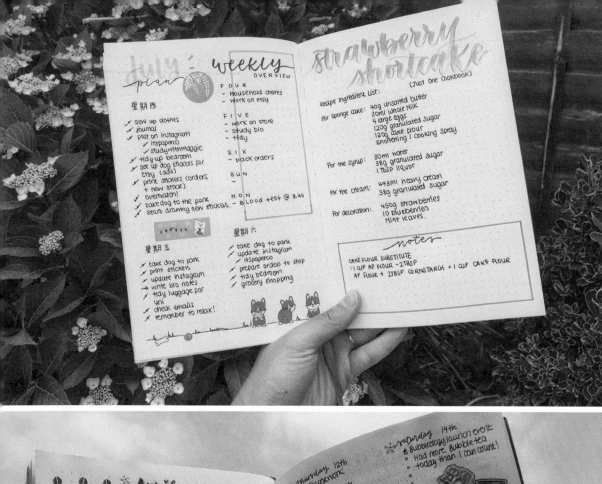
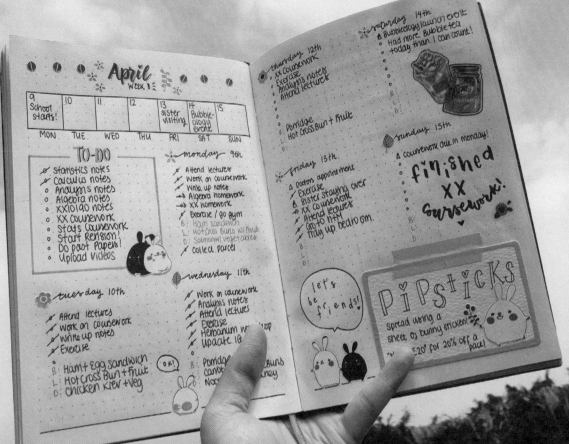

july
plan

weekly
OVERVIEW

FOUR
- household chores
- work on etsy

FIVE
- work on store
- study bio
- tidy

SIX
- pack orders

SUN
-

MON - BLOOD test @

星期四

- ✓ sew up clothes
- ✓ journal
- ✓ post on instagram
 - ✓ itspaperco
 - ✓ studywithmaggie
- ✓ tidy up bedroom
- ✓ set up dog stickers for etsy (ads)
- ✓ print stickers (orders + new stock)
- ✓ overwatch!
- ✓ take dog to the park
- ✓ start drawing new stickers.

イタダキマス

星期五

- ✓ take dog to park
- ✓ print stickers
- ✓ update instagram
- → write bio notes
- ✓ tidy luggage for uni
- ✓ check emails
- ✓ remember to relax!

星期六

- ✓ take dog to park
- ✓ update instagram
 itspaperco
- ✓ prepare orders to
- ✓ tidy bedroom
- ✓ grocery shopping

strawberry shortcake

(Just One Cookbook)

Recipe Ingredient List:

For sponge cake:
- 40g unsalted butter
- 30ml whole milk
- 4 large eggs
- 120g granulated sugar
- 120g cake flour
- shortening / cooking spray

For the syrup:
- 30ml water
- 38g granulated sugar
- 1 Tbsp liquor

For the cream:
- 473ml heavy cream
- 38g granulated sugar

For decoration:
- 450g strawberries
- 10 blueberries
- Mint leaves.

notes

CAKE FLOUR SUBSTITUTE
: 1 CUP AP FLOUR - 2TBSP.
AP FLOUR + 2TBSP. CORNSTARCH = 1 CUP CAKE FLOUR